# Kathy Lamancusa

## ❧ Guide to ❧

# Decorative Painting

**TAB** TAB BOOKS
Blue Ridge Summit, PA

D0517279

**Notices**

| | |
|---|---|
| **Crafter's Cement®** | Loctite Corp. |
| **Super Glue®** | |
| **Styrofoam®** | Dow Chemical Corp. |

FIRST EDITION
FIRST PRINTING

© 1992 by **TAB Books**.
TAB Books is a division of McGraw-Hill, Inc.

Printed in the United States of America. All rights reserved. The publisher takes no responsibility for the use of any of the materials or methods described in this book, nor for the products thereof.

**Library of Congress Cataloging-in-Publication Data**

Lamancusa, Kathy.
    Decorative painting / by Kathy Lamancusa.
      p.    cm.
    Includes index.
    ISBN 0-8306-1933-X  ISBN 0-8306-1931-3
    1. Decoration and ornament.  2. Painting.  I. Title.
TT385.L36  1991
745.7′23—dc20                    91-28916
                                     CIP

TAB Books offers software for sale. For information and a catalog, please contact TAB Software Department, Blue Ridge Summit, PA 17294-0850.

Acquisitions Editor: Kimberly Tabor
Book Editor: April D. Nolan
Production: Katherine G. Brown
Page Makeup: Wendy L. Small
Book Design: Joanne M. Slike
Full page color photography by: Shawn Wood, Studio 7, North Canton, OH
Black and white photography by: Visual Design Concepts, North Canton, OH

## Dedication

*This book is dedicated to my son Jim. He is a super-special kid who will grow up to be an exceptional adult. I am very proud of all of his accomplishments and truly appreciate his love of home and family.*

*Jim, you must always remember that you are talented enough to do anything you set your mind to. You are very creative, and I know that you will go a long way and be very important and valuable to many people. When you touch the hearts and souls of others, you fulfill yourself. You are a wonderful person—and I love you very much!*

# Contents

## Part II
# Painting Projects

## 7 Special Holidays 85

## 8 Home Decorating 107

# ᔓ Acknowledgments ᔔ

I would like to thank the following people who assisted in creating this book:

*Joe*—my son, who gave me a hand!

*Diana Williams*—who painted many of the models used for photography.

*Mary Annette Salpietra*—many of the wooden pieces were embellished with flowers, ribbon, and more by her capable hands.

*Casimir Wielicki*—my dad, who hand-made the beautiful inlaid table shown in many of the full-color photographs.

. . . and, as always, my husband, Joe, whose constant support made this book a reality!

# ᔓ Suppliers ᔔ

The following companies supplied products for use in the preparation of this book:

AMERICAN OAK PRESERVING CO.
601 Mulberry St.
North Judson, IN 46366

C.M. OFFRAY & SON, INC.
Route 24 Box 601
Chester, NJ 07903

DECO ART AMERICANA
P.O. Box 360
Stanford, KY 40484

LION RIBBON COMPANY
100 Metro Way
Secaucus, NJ 07096

LOCTITE CORPORATION
4450 Cranwood Court
Cleveland, OH 44128

RHYNE FLORAL SUPPLY
P.O. Box 310
Gastonia, NC 28053

WALNUT HOLLOW FARM
Rt. 2
Dodgeville, WI 53533

ROBERT SIMMONS, INC.
45 W 18th St.
New York, NY 10011

# ❧Introduction❧

Painting can be a frightening experience for a beginner. Many believe that only "creative," "talented," and "gifted" people can paint, but nothing could be further from the truth. By following the steps in this book, anyone can become comfortable with decorative painting—and anyone can produce an excellent finished design.

In planning this book, I chose only the easiest strokes, techniques, and designs. Once you have mastered the basic steps, you can easily use what you have learned to begin designing your own pieces.

*Kathy Lamancusa's Guide to Decorative Painting* will carry you through each technique, step by step, with lots of support through photos and drawings. In Part One, you will learn all the basic steps you need to know for decorative painting as well as how to care for and use acrylic paints and brushes. Sealing, transferring patterns, and applying a finish are all important aspects to the longevity of the finished pieces and these, too, are explained in detail. You'll also learn how to prepare old and new wood for painting.

Because the use and care of brushes is so important, I have devoted a great deal of time to explaining it. You'll learn several brush strokes and interesting effects such as antiquing, speckling, country sanding, and sponge painting. You'll also learn to paint calico designs, waves, clouds, ruffles, and lace.

In Part Two, you'll see all the basic steps and techniques you've learned actually put to work. In chapter 5 these techniques are used to create a multitude of animal shapes and designs. We have designed projects for men, women, and children alike, as well as projects for holidays. Paint a goose for Christmas, napkin holders for a special dinner, or teddy bears for a child. Use these patterns to trace onto other wooden pieces, purchase them in pre-cut shapes to paint, or cut out your own animal shapes.

Chapter 6 is devoted entirely to decorating for children, using two basic themes, nautical and nursery. Although several projects are included, you can use your imagination and add the nautical motifs to other decorative pieces or to practical items such as bookshelves, beds, and dressers. In this chapter, calico patterns and speckling technique are dominant.

When you want to create special painted pieces for holiday giving or for decorating, turn to chapter 7 where you'll find projects designed for Halloween, weddings, Christmas, Easter, and more. Create several hearts for Valentine's day and special gifts for Mom and Dad.

Chapter 8 will give you several wonderful ideas for adding simple or elaborate embellishments to both home decor items and furniture pieces. You'll learn to add interest by using combinations of color, interesting strokes, and dazzling techniques. And wooden items aren't the only things you can paint. In chapter 8 you will also learn to form a wreath out of bread dough, then paint it to look like calico. Ribbon is also cut and used to resemble intricately painted designs.

You *can* paint—quickly and easily. Soon you will be designing your own projects for your own home or to give as gifts. The recipient of your specially painted treasure will be pleased and amazed—and you can say, "I made it myself!" Enjoy painting. I know you will love it as much as I do.

# Part I

# Getting Started

# Painting Supplies

*A* multitude of supplies are available on the market. You'll be able to find everything you need at your local art supply or craft shop. In some cases the supplies are common items that you use daily in your own home.

As you begin decorative painting, set up an area in which you will work. Plan storage for your supplies. It is quite frustrating to hunt for your materials every time you want to use them. Often you might be drawn away from your work before you have had a chance to complete a project. Having an area set aside will allow you to leave and return without tearing everything down and setting it up again.

For storage space, you can use shelves, closets, cupboards, storage boxes, or even an inexpensive set of drawers purchased for this purpose. A tote box (fishing tackle or art box) is excellent to store supplies for transport.

Always take the utmost care with all your supplies. Read all package directions and warnings, and follow them carefully. Never store substances in containers that could be mistaken as edible food items. For example, rubbing alcohol in a food-storage container could be mistaken for water. Clearly mark all substances if they are removed from their original containers, and keep all supplies out of the reach of children and pets.

## ACRYLIC PAINTS

Acrylics are water-soluble paints available in tubes, jars, and squeeze bottles. Many varieties exist on the market, but they are not all alike. Each brand has its own strengths and weaknesses.

The other type of paint sometimes used for decorative painting is oil paint. Oil paints, obviously, are oil-based. They require strong solvents

for clean-up, and they take much longer to dry. Although we will not be painting in oils in this book, the techniques used here could still be used with oils. While oils are sometimes easier to blend, acrylics tend to retain a brilliance of color over time.

Some acrylic paints have been formulated to follow the characteristics of oils, others have not. The more fluid paints are packaged in bottles or jars, while thick varieties are available in tubes. You might wish to begin with the bottles or jars, try the tube varieties later to get a real feel for the art; then choose which you personally enjoy better.

Acrylics are easy to mix, but in many cases, so many varieties of color are available that mixing isn't necessary. Brands of paint vary in many ways. Probably the greatest variation is in the amount of pigment used. The pigment gives the color its deep rich look. With some paints you might need to paint two or more coats to get full coverage. With other paints, one coat of paint will be sufficient.

# Drying Times

The drying time of acrylics vary and are affectd by different factors. Plan on increased drying times when:

○ Weather is cold or damp

○ Humidity is high

○ Heavier coats of paint are applied

○ Specific strokes using heavier thicknesses are used such as dots or textured strokes

Decrease drying times when:

○ Weather is very hot and dry

○ Surfaces or parts are warmer

○ Situations of forced drying

Generally, acrylics dry in 10−30 minutes, depending on the brand. I recommend that you allow paints to dry 2−24 hours before varnishing.

It is important that you allow paints to dry when moving from step to step in the progression of the design. During the drying process, moisture is evaporating from the paint, so the paint will feel cool to the touch before it is dry. Acrylics have a shiny finish when first applied to the surface. As the paint dries, the shine disappears, and the piece will have a *matte* or dull appearance.

Always shake your paints to mix the pigments before you use them. Wipe off the lids, spouts, or edges of the jars, tubes, or bottles. This will keep the caps tightly closed so the paint does not dry out, but it also will

permit easy opening and closing of the product. Shelf life of paints can be decreased if they are exposed to extreme heat or cold.

Follow one of the following steps to retard the drying time and keep paints fresh while you are working with them.

○ Use a painters palette or tight sealing kitchen container for storing opened paints.

○ Spray a fine mist of distilled water periodically over the paints—not too often, though; it can dilute the paints.

○ Use a plastic tub, bowl, or lid placed firmly over the paint on the palette.

○ Squeeze thicker tube paints directly onto a dampened paper towel to use.

○ Extender or retarder are products manufactured by each specific paint company and when added to the acrylics, lengthen their drying time.

# OTHER SUPPLIES

You can save yourself a great deal of time and effort simply by having the right tools and supplies on hand for your decorative painting projects. The following are some things that will make your new craft easier and more enjoyable.

☐ *Acrylic palette*  Palettes are designed to hold paint while you work. In some cases, they can be sealed for short amounts of time between uses. They save paint and time and are great to use. The best paper to use inside your palette is nonabsorbent coated paper. You can use a rectangle plastic storage box with a lid instead of purchasing one of the palettes marketed to painters. Be sure to pick a size that will hold a pad of palette paper inside.

☐ *Acrylic gel*  When added to opaque colors, acrylic gets transparent, but their consistency doesn't change.

☐ *Acrylic sealer*  Sealers are used to prepare basecoated surfaces before further paint application. Others uses vary from product to product and are listed on each can. Follow the directions on the can.

☐ *Alcohol (rubbing)*  Alcohol removes the soap residue that remains on your brush after cleaning. Glue a small sponge in the bottom of the alcohol bottle and gently run the brush along the sponge to clean out the residues of paint. It is important that you rinse all alcohol from the brush before you continue to paint.

☐ *Baby wipes*  Because most baby wipes are coated with alcohol, they can quickly clean mistakes on your work before it dries. They are also useful for cleaning your hands when you are done working.

☐ *Brushes*   You will need a variety of brushes determined by the types and sizes of items you are painting. (See chapter 3 for details about brushes and brush care.)

☐ *Brush basin*   A brush basin holds water for cleaning brushes. Distilled water is best for cleaning brushes, many impurities and additives found in tap water can affect the paints.

   It is best to use the type of basin that has ridges along one side of the bottom. Running your brush in one direction across the ridges makes cleaning easier. If you can't find such a brush basin, create your own by gluing a synthetic sponge to the bottom of a margarine tub. Use one basin for cleaning brushes and one for floating color. Soap residue from brush cleaning will diminish the adhesive qualities of the paint.

☐ *Brush cleaners*   Commercial versions of brush cleaners are available, but a bar of Ivory soap or Loctite's Fast Orange Hand Cleaner works fine.

☐ *Brush holders*   Because brushes are expensive, utmost care should be taken to protect them. Always store them bristle-side up. You can use a jar, can, or mug for storing. You might wish to fill the container halfway with sand or rice to support the brushes. Commercial brush holders are available and if you plan to transport brushes, I highly recommend investing in one of these.

☐ *Chalk*   You'll need chalk to transfer patterns or to sketch freehand designs. Either use child's blackboard chalk or chalk pastel pencils. Use white for dark surfaces and colored chalk for lighter ones.

☐ *Cotton swabs*   Not only are cotton swabs used for cleaning up messes but they are also useful for painting some projects.

☐ *Crackle medium*   This material creates an aged, weathered, crackled appearance.

☐ *Designer painting tools*   Designer tools have a specific design on the top of a pencil-like tool. They are dipped into paint, then placed on the design. Many styles and types are available. Some include hearts, dots, commas, teardrops, letters—even holiday and special designs.

☐ *Drafting tape*   Such tape is used to attach patterns to the surface when tracing a design.

☐ *Eraser*   A wet-paint or gum eraser work best for correcting mistakes. Store these in plastic bags between uses.

☐ *Extender*   Extenders are used instead of water to increase the transparency of paint. They are also useful for extending the length of drying time.

☐ *Gesso*   A primer for acrylics, gesso is used to seal most surfaces. It is effectively used to seal wood, clay pots, canvas, plaster, and masonry before painting.

☐ *Glue*   You will use glue to attach pieces together or to add painted pieces into designs. Specific glues work best for specific surfaces. Check the packages for recommendations.

    A glue gun is great for general uses. However, always be careful when using a glue gun; the extruded glue is very hot.

☐ *Graphite transfer paper*   Graphite is not carbon paper. Do not use one in place of the other. Graphite is gray or black paper used to transfer designs onto the surface that will be painted.

    When using a new sheet, begin by wiping excess graphite from the surface of the paper. Be sure not to make the initial patterns too dark. Store the paper by folding it graphite-side in and place it in a folder or bag. For projects with a dark surface transfer paper is also available in lighter colors, including white.

☐ *Hair dryer*   Hand-held hair dryers are very useful in speeding up drying time. Use only on low setting at least 12 inches from the surface. Thicker paints will crack if they are dried quickly.

☐ *Palette paper*   These papers are disposable pads used for blending colors before painting. Be sure the type you buy is for acrylic use.

☐ *Palette knife*   It's useful to have a palette knife for mixing paints, removing paints from jars, and adding textural effects. The best types of knives are stainless steel or plastic. Clean them after each use; paint is difficult to remove when it has dried.

☐ *Paper towels*   You should have lots of these on hand. They are used for brush-blotting and for cleaning up.

☐ *Pencil and notebook*   No artist should be without a notebook and pencil for catching his or her thoughts and ideas before they slip away.

☐ *Permanent marking pen*   Be sure your pen is not the waterproof type. It is used for patterns, marking names, and even drawing some linework on the finished piece. I like the thin-point, black varieties.

☐ *Rags*   These are useful for antiquing and for many other jobs.

☐ *Ruler*   A ruler is essential for measuring patterns and line work.

☐ *Sandpaper*   Have several grades of sandpaper on hand, from medium to very fine grade (such as 400-grit to 600-grit papers).

    Sandpaper is used before and after sealing to smooth the wood and after basecoating the surface. I like to use brown grocery bags at times for sanding after basecoating.

☐ *Sealers*  Many varieties of sealers are available. Choose the one that best fits your applications. Sealing must be done on most surfaces for better adhesion of paint.

☐ *Sponge brushes*  Usually these are double- ended, having a wooden handle and metal bulb on each end. The two bulbs are different sizes and can be used for forming two different sizes of dots.

☐ *Tack cloths*  Such cloths are specially treated to remove sanding residue easily.

☐ *Turntable*  A turntable allows you to turn your piece with the touch of a finger. Because you don't have to touch the project to turn it, this allows for less fingerprints on the piece.

☐ *Tracing paper*  Tracing paper is transparent paper useful for transferring patterns. It is placed over graphite, not used in place of it.

☐ *Varnish or sealer*  A varnish is used to protect a finished painting. Both brush-on and spray types are available, in matte, satin, semi-gloss, and gloss finishes.

☐ *Wood stains*  Stains for wood are available in water- and oil-base varieties and are used to treat and color wood before painting.

## CHOOSING THE RIGHT ADHESIVE

A wide variety of adhesives are available in the market today. When you choose one, be need-specific: Know what you want to glue together, then choose the glue that will do the job. Here are some specifics about product catagories that should assist you in your decision making process.

☐ *Crafter's Cement*  This variety of adhesive is an ideal alternative to white glue. It is a slow-set adhesive, which allows the designer to be creative and alter pieces as the design is being created. It is not affected by temperature changes and is perfect for attaching flowers and ribbons (FIG. 1-1).

☐ *Clear silicones*  Silicone should be the product of choice when you want to add depth to dimensional projects. Its ability to bridge gaps and ridges makes it perfect for porous substances such as fabrics, flowers, and styrene foam. Clear silicones are also waterproof, which makes them the choice when attaching glass pieces and planter boxes together. It is also an excellent outdoor adhesive (FIG. 1-2).

☐ *Project Plus*  This two-part adhesive provides a bond that resists moisture and solvents. It works best on hard-to-bond items, such as metals, plastics, and glass (FIG. 1-3).

**Fig. 1-1**
Crafter's Cement has a
multitude of uses.

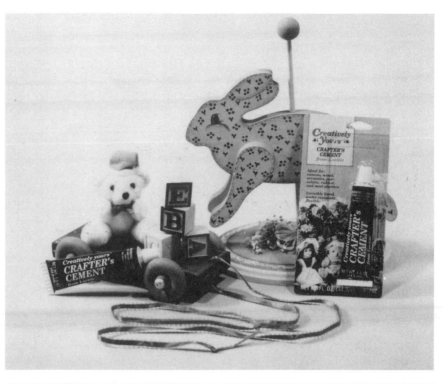

**Fig. 1-1**
Crafter's Cement has a
multitude of uses.

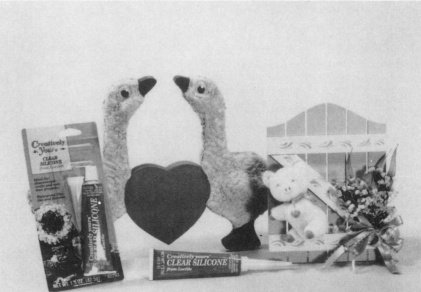

**Fig. 1-2**
Clear silicones are perfect
for outdoor uses.

**Fig. 1-3**
When two materials are difficult to bond with traditional adhesives, Project Plus by Loctite might be the answer.

☐ *Super Glues*   Considered instant adhesives, Super Glues work great on wood and for attaching beads, jewels, flowers, and other embellishments. Super Glues are available in gel formulas that bond to more surfaces and work faster. You can also get glue pens with pin-point accuracy tips (FIG. 1-4).

☐ *Glue guns*   The all-purpose, quick adhesive, hot glue works in most applications. The one exception is that it is not recommended for outdoor use (FIG. 1-5).

**Fig. 1-4**
Super Glues are available in many forms.

**Fig. 1-5**
Glue guns are all-purpose
and work on most
applications.

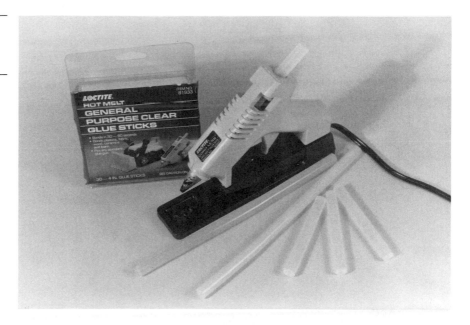

# Preparing & Finishing

*P*reparing the surface on which you will be painting is vital to the success of your project. Improper preparation can cause the paint to peel off of the surface. Should this happen, it is extremely difficult to repair the damage. Therefore, I highly recommend that you take the time to properly prepare each surface.

The general instructions for preparation in this chapter are the techniques I have found to be most helpful. You might find that preparation techniques vary slightly from artist to artist.

A sealer is applied to the surface to be painted for a number of reasons. First, it creates a barrier between the object and the paint. This barrier controls any moisture or chemical reactions which may occur between the surfaces. Secondly, it assures a proper surface for the paint to adhere.

Finishing is just as important as preparing. If finished improperly, the most beautifully painted piece can be ruined without hope of repair.

The finishing coat protects the painted piece from the potential of environmental reactions. Possible problems include oils, alcohol, smoke, strong cleaning solutions, moisture, and human fingerprints.

The small investment made in proper finishing will protect many hours of work and preserve your treasures for generations to come.

## PREPARING WOOD

Either new or old wood can be used for decorative painting, but keep in mind that more preparation steps are necessary for old wood. Be sure to follow all steps very carefully; your beautiful painting will not be as attractive on a poorly prepared surface.

# Old Wood Surfaces

You can create a delightful treasure from an old piece of wood or furniture you might find in a thrift store, a garage sale, or even your own attic. Follow these steps when preparing an old piece of wood:

1. If the old finish is flaking, chipping, cracking, or if the corners and edges are highly worn, you'll need to strip the wood first. Without stripping, your painting might peel away. Purchase a commercial stripping product from your hardware store and follow the package instructions. Be sure to remove all metal hardware prior to stripping.

2. If the wood does not need to be stripped, it should still be thoroughly washed with detergent and water to clean off any build-up of wax, grease, or dirt. Rinse the piece well and allow it to dry.

3. After either Step 1 or 2, continue from Step 1 in the "New Wood Preparation" information.

# New Wood Surfaces

When choosing wood for painting, you should consider whether you will stain or basecoat the piece. If you are staining, the grain of the wood will be quite noticeable and, therefore, should be chosen for its attractiveness. If you are basecoating it, the grain will not show, so its appearance doesn't matter.

Before either staining or basecoating, follow these steps to prepare the wood:

1. Sand the wood with a fine- to medium-grit sandpaper. When sanding, always follow the direction of the grain of the wood.

2. Remove all sanding residue with a tack cloth.

3. Countersink any nails in the wood. Fill all nail holes, joints, or cracks with wood filler. Follow the package instructions when you apply wood filler. At times, it will not blend with the color of the wood. This isn't a problem if you basecoat, but if you have decided to stain the wood, be careful.

4. After the wood filler dries, sand these spots to smooth and again wipe with tack cloth to remove the residue.

5. Using a sponge brush, apply your wood sealer. Some fine-quality, spray-on wood sealers are also available.

6. After the sealer has dried, re-sand the piece. You'll find that the sealer has raised the grain of the wood, and it will again feel rough to the touch. Use the tack cloth after sanding. Pieces of brown paper grocery bag work well as a sanding medium in some cases.

You may then choose one of the following options to continue:

1. *Natural Wood* If the look of natural wood for the background is desired, simply transfer the pattern at this point. This process will be explained later in the chapter.

2. *Basecoat* Using a sponge brush, apply the acrylic paint of your choice in smooth, even strokes. This is called *basecoating*. Cover the entire surface. Depending on the brand of paint you choose, you might need more than one coat of paint. Let each coat dry and lightly sand it before adding the next coat.

3. *Stain* Apply a wood stain to the wood following package instructions to accent the grain of the wood. Allow it to dry, then sand it and use the tack cloth.

## TRANSFERRING THE PATTERN

After your wood is prepared, you will need to transfer the desired pattern to the wood.

To begin, you need to first transfer the pattern from the book. Simply lay a sheet of tracing paper on top of the pattern and outline it with a felt tip marker. Be as accurate as possible, and trace the entire pattern. If the pattern doesn't exactly fit your wood piece, you can enlarge or reduce the pattern with a photocopying machine that has these capabilities. Most quick printers will be able to do this for you very inexpensively.

Whenever you copy materials from copyrighted books, it is important to keep the copyright laws in mind. You are permitted to make copies, enlargements, and reductions for your own use only. It is against the law to give these away or to sell them to others.

When you transfer the pattern, transfer only the lines you will need for the next step. The rule is, "The fewer the better." First transfer the lines separating the largest sections, then basecoat these areas. After the basecoating is dry, add the lines that accent each area, known as *secondary lines*. Some lines should just be done in freehand strokes, without a guiding mark, such as commas, dots, dashes, and stitching lines. Intricate areas such as eyes should be transferred before being painted.

## Transfer Methods

You can use any of the different methods to actually transfer the patterns. Try all of them to see how they work, then choose your favorite method for each future project you do.

☐ *Chalk transfer* This is a quick, easy method that many painters love. Simply purchase blackboard chalk: Avoid artist chalk because its composition is different, and it doesn't work quite the same.

After you trace your pattern, turn the pattern sheet over and trace over the lines with the chalk. You don't have to be exceptionally neat, but be sure all lines to be transferred have chalk on them. Shake the transfer paper to get rid of chalk dust.

Place the pattern chalk-side down on your board and tape it in place with drafting or masking tape. Trace the main pattern lines with a stylus, a pencil, or a ballpoint pen that has run out of ink. Occasionally lift back the pattern to make sure the lines are appearing clearly. You might need to adjust the pressure of your stylus or perhaps even re-chalk the pattern. Do not press hard enough to make ridges in the wood, they are undesirable in your finished work.

After basecoating, you may add detail in the same manner, however, other colors of chalk might be more appropriate.

☐ *Graphite transfer*   Technically only the gray or black color of transfer paper is called graphite. All other colors are merely transfer paper. Before using a new sheet, wipe the shiny side down with a rag to remove excess color.

Place the transfer paper shiny-side down, under the taped pattern sheet. Again trace the necessary lines. Be careful not to trace the pattern too darkly as it will detract from the finished piece and might even smear. Lift up the sheets to check yourself along the way.

After tracing, remove any stray lines with a kneaded eraser before continuing. If you have traced the lines too dark, lighten them with the eraser before you paint.

You can make your own graphite paper. Turn your pattern sheet over, then rub a soft lead pencil across the back of the tracing. Lay it pencil-side down, tape it in place, and trace.

After painting, again erase any stray lines that appear on your painting.

# FINISHING YOUR WORK

You should always protect your work with a finishing varnish coat. The finishes will vary in appearance and can be matte, gloss, semi-gloss, or satin in brush-on or sprays. Choose the finish which best complements your work.

Even if you are only applying a matte finish, it is important to apply enough varnish for the preservation of your work. The finish is the only thing that protects your work from environmental hazards and natural wear and tear over time. Ask for assistance at your local shop to see which finish would work best for your project. Read the instructions carefully, and follow them explicitly.

# Brush Care & Basic Strokes

lways take great care when using and cleaning your brushes. Purchasing good brushes is something you should consider if you plan to do a lot of decorative painting. Proper care will ensure that this investment lasts a long time.

If you plan to paint with oil paints as well as acrylics, you should have a separate set of brushes for each. Because oil-based paints are repellant to water-based products, the two don't often work well together. Also, the acrylic paints are a courser material and tend to be harder on the brushes.

You can do permanent damage to a brush if you place undo pressure on its edges or point, or if it is exposed to excessive twisting or pushing during loading, use, or brush cleaning. Just allow the hairs to move in their own natural direction for best results.

Do not allow excess paint to work its way into the base, or *ferrule*, of the brush. It is extremely hard to remove, and it might cause the brush to bulge, resulting in a misshapen brush.

Sizing is applied to all new brushes to protect them during shipping. Rinse it out with cool water before you use the brush.

Paint should never be allowed to dry on the brush. Acrylics dry quickly, so take special care to keep the brush moist until you can clean it properly. Rinse your brushes often during brush or color changes. Change the water often to avoid build-ups. Be sure to completely clean all brushes after each painting session, and always store brushes flat or placed upright, resting on their handles. Never allow brushes to rest on their bristles.

Some tips for cleaning your brushes:

1. Begin by removing excess paint on the brush by wiping it across paper towels or a roll of toilet tissue.

2. Gently swish the brush in cool water. Don't use warm or hot water, it helps paint dry quicker.

3. Apply a brush cleaner (following the manufacturer's instructions) or stroke the brush through a bar of Ivory soap. After gently working the soap through the brush, clean the soap out by again swishing through cool water. The use of a commercial brush-cleaning tub is helpful. You may also glue a sponge to the bottom of a dish, then stroke the brush over the sponge to remove paint and soap.

4. Remove the excess moisture and reshape the brush with your fingers.

5. Apply a brush sizing or conditioner to help restore the brush between uses. Rinse the sizing out before using the brush again.

## CARING FOR ACRYLIC PAINTS

It's helpful to know a few things when using acrylic paints. Following these steps will be important to the quality of your finished work.

Always shake the jar or bottle before using the paint. Gently squeeze or shake tube acrylics to adequately mix them.

Rinse soap residue from brushes completely before using them with your acrylics. The soap will hinder the adhesive qualities of the paint. Also, never use soapy water to rinse brushes between colors while painting.

Always clean off the spout, tube, or jar edges with a paper towel before closing. Dried paint will hamper a tight fit and might cause the paints to dry out prematurely. Remember, too, that the shelf life of your acrylics will be affected when the product is exposed to extremes of temperature.

Because acrylics dry so quickly, care should be taken during painting to keep them of a painting consistency.

Place your paints in a commercial paint palette with a lid, or use a large flat plastic container with a tight lid. During use, mist the paints on the palette periodically. After using them, cover your paints with plastic bowls or cups.

If your tube acrylics are very thick, you can squeeze them onto dampened paper towels while working.

You could use a paint extender that is designed to go with your particular product. Ask your supply store for help in choosing one, then follow the manufacturers instructions.

Acrylic paints should always be allowed to thoroughly dry between steps of painting. When wet, acrylics are shiny and feel cool because of moisture evaporating. When dry, the colors take on a matte or dull look.

# BASIC BRUSH STROKES

As you learn to paint, it is important to master the basic brush strokes which are used to create several of the pieces in this book. Combinations of these strokes can create a limitless number of new and exciting patterns for your work.

When using these strokes it is really important to remember that they are best created freehand. Do not draw the lines you see in the patterns for commas, dots, etc. These marks are merely to give you an idea of where the stroke should be placed. If you wish to add to or subtract from these designs, do so! Enjoy. Create. Use your imagination!

# Comma Stroke

The comma stroke is one of the most fundamental and important strokes you will ever learn. The uses for it are endless! It can be created with either a flat or a round brush. The only difference in the finished stroke is that with a square brush, the end will be flatter than when the stroke is made with a round brush (FIG. 3-1).

**Fig. 3-1**
A round brush will leave the top of a comma stroke rounded; a square brush will leave it flat.

Regardless of which brush you choose to use, the formation of the stroke is identical.

1. *Fully load* the brush with paint by stroking the brush through the paint until it is completely covered.
2. Press the brush onto the painting surface gently allowing the bristles to spread out (FIG. 3-2).
3. Start to pull the brush toward you, maintaining the pressure. Gently begin the curve on the stroke (FIG. 3-3).

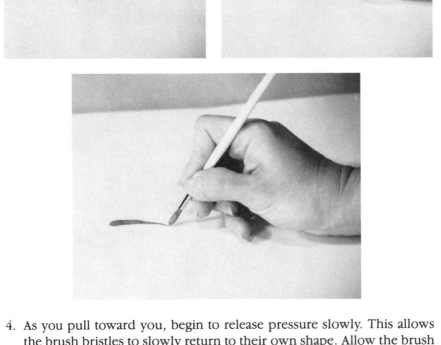

**Fig. 3-2** (Left)
Press the brush onto the painting surface allowing the bristles to spread out.

**Fig. 3-3** (Right)
Pull the stroke and begin to curve it.

**Fig. 3-4**
Release the pressure on the tail bringing it to a thin line.

4. As you pull toward you, begin to release pressure slowly. This allows the brush bristles to slowly return to their own shape. Allow the brush point to make a thin tail on the comma. Then release all together (FIG. 3-4).

   You can add embellishments to dress up these strokes:

1. Add a dot of a contrasting color to the widest part of the comma (FIG. 3-5).

2. Form a triple comma stroke by placing a smaller comma on top of a larger one, then a tiny comma in the center of the other two. Use three consecutive sizes of brushes and coordinating colors (FIG. 3-6).

3. A comma heart is formed with two commas, formed straight up and down, placed very closely side by side. The larger the size of the brush, the larger the heart will be (FIG. 3-7).

4. To form leaves, simply make a comma stroke straight up and down, then place a single stem line from the center of the widest portion of the comma with a liner brush (FIG. 3-8).

**Figs. 3-5, 3-6, 3-7, 3-8**
Comma stroke variations. From left to right: Fig. 3-5 comma with dot; Fig. 3-6 triple comma; Fig. 3-7 comma heart; Fig. 3-8 comma leaf.

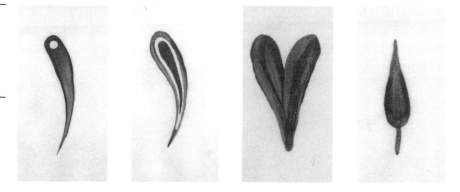

# Dots

Dots can be added together in various sizes to create a number of wonderful looks. They are easy to create and should never be placed on the piece by transfer; rather, they should always be done freehand.

Tools you can use to make dots (choose one):

☐ end of a paintbrush
☐ toothpick
☐ city chicken skewer
☐ stylus
☐ commercial dot tools

**Dots**   Dip the end of the paintbrush or other tool in the paint. Touch the brush to the paper—you'll see a perfect dot. Continue to dip the tool in the paint and touch the painted piece (FIG. 3-9).

**Decreasing Dots**   If you wish to make a series of decreasing dots, simply do not reload the brush after the first dot, but continue to make dots in a row. Usually 4 to 6 dots can be made depending on how much paint was first on the brush (FIG. 3-10).

**Flowers**   Start with a color for the center dot. Change colors and form 5 or 6 more dots equally surrounding the first dot (FIG. 3-11).

Consider some of the dot designs in FIG. 3-12 for your own work. Change the sizes and colors for variations.

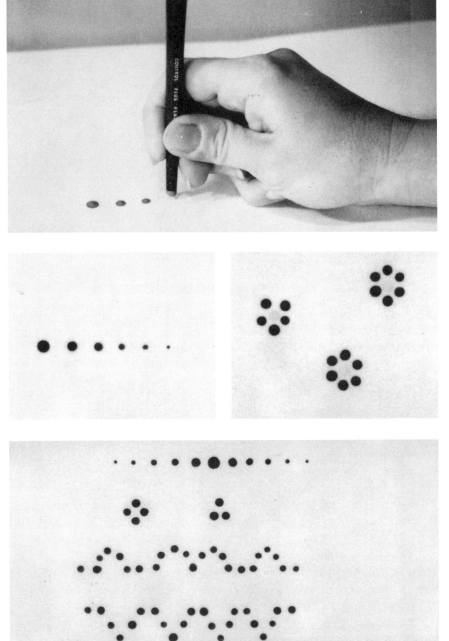

**Fig. 3-9**
A dot can easily be made with the end of a paintbrush.

**Fig. 3-10** (Left)
Don't add more paint to the brush when creating decreasing dots.

**Fig. 3-11** (Right)
Dot flowers are easy to make.

**Fig. 3-12**
Use your imagination in creating designs with dots.

## Stitching Lines

Use a liner brush to create stitching lines. Completely fill the brush with paint, then hold the brush as though it were a pencil. Gently touch the design, and then quickly and delicately pull it toward you. Release and draw the next stitch (FIG. 3-13).

**Fig. 3-13**
Thin the paint when drawing stitching lines.

Stitching lines can also be made using a fine line marker or pen. Other combinations using the dots and stitching lines together are shown in FIG. 3-14.

**Fig. 3-14**
Combine dots and lines for interesting effects.

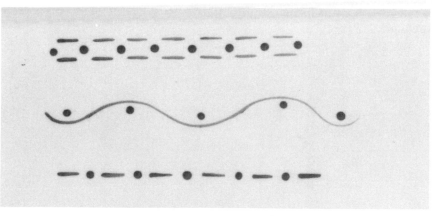

## Using a Liner Brush

The use of a liner brush can be a little tricky; practice on your tracing paper until you are comfortable with the look of your finished work and the feel of the brush.

Don't transfer the liner brush lines onto your work surface; do these areas freehand. Your finished look will be more free-flowing and not as stilted. Also, because the paint will be thinned down, your graphite lines might show through and be distracting.

Fill your liner brush with water, then stroke it through the paint until the paint flows like ink. Continue to stroke the brush through the paint until it is fully loaded. Liner brushes can be filled up to the ferrule.

When the brush is fully loaded, there should be paint contained in the center. Twirl the brush tip on the palette until it forms a point. Test by drawing a line on your palette. If it moves smoothly, begin on your finished piece. If it doesn't, add a drop more water, and reload the brush.

# Eyes

Eyes can be the most striking portion of a design when painted correctly. On the other hand, if they are painted incorrectly, they make the finished piece look dull and lifeless. Some of the items which are important when painting eyes are: the dot highlight, the comma highlight, and the eyelashes.

When creating an animal eye, transfer the pattern from the individual instructions. First paint the entire darkened area black. Add the eyelashes with a liner brush, and form the shaded area under the eye with a wide, flat brush side loaded with the designated color.

Add the highlights last, allowing the paint to be slightly thicker than normal. This thickened paint adds some dimension to the eye and helps it to stand out. The dot is made with the end of a paintbrush and the comma is made with a small round brush. Always use white or eggshell for these highlights.

# Painting Techniques

$\mathcal{S}$ome of the many available painting techniques are explained in this chapter. These techniques are then used in the projects designed later in the book.

Figure 4-1 shows the alphabet used in this book. The letters can easily be drawn using a liner brush with thinned paint. For a crisper look, use a fine line marker.

## CALICO

When painting calico designs, it is important to coordinate colors of the overall piece. Always begin by drawing the main areas of patchwork lightly on the design. Basecoat each area with its appropriate colors. Calico designs should always be done freehand. They are usually too intricate to draw or trace from a pattern.

Individual calico designs are shown throughout the book. Use these, or add your own touch of imagination and creativity.

## SIDE LOADING/FLOATING COLOR

Some artists use the terms *side loading* and *floating color* interchangeably; to other artists they might mean two different things. Be sure to read through the basic instructions in the book you are using to better understand what techniques the author is incorporating. In this book, the two terms refer to the same process.

Side loading/floating color will add depth because of the shading aspect of dark to light. This technique is well worth spending the time to perfect your skills. It is one of the techniques you will use most often.

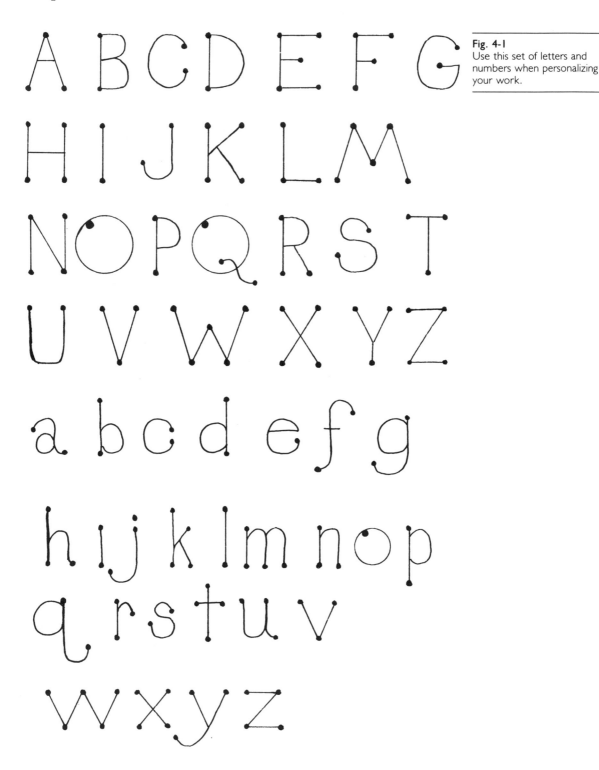

**Fig. 4-1**
Use this set of letters and numbers when personalizing your work.

A flat brush is used throughout this book for side loading. Choose the largest brush compatible for the area in which you are working.

You will be striving to move gradually from a dark color on one side of the brush to no color on the other. The color will gradually fade across the bristles.

Begin with a fresh pile of paint and clean water, as well as a clean, flat brush. First dip the brush into the water, then touch the tip to a paper towel to eliminate excess moisture. Gently touch one edge of the brush into the edge of the puddle of paint (FIG. 4-2). Draw the brush backwards through the paint, then stroke the brush back and forth a few times on a

**Fig. 4-2**
Dip the side of a flat brush in a puddle of paint.

clean area of the palette until the color is worked through half of the brush and it fades to nothing on the other side (FIG. 4-3).

When you feel you have the right look on the palette, dip the painted side of the brush slightly—and I emphasize *slightly*—into the paint, brush one more time on the palette, then apply to your design in one stroke with the painted side on the dark side working to no color. This stroke should perfectly blend over the basecoat of the design. The consistency of the paint will be a little thinner than usual.

Figure 4-4 shows a correctly formed stroke, and FIG. 4-5 is incorrect. Practice this stroke often and before you know it, your side-loading technique will be perfect.

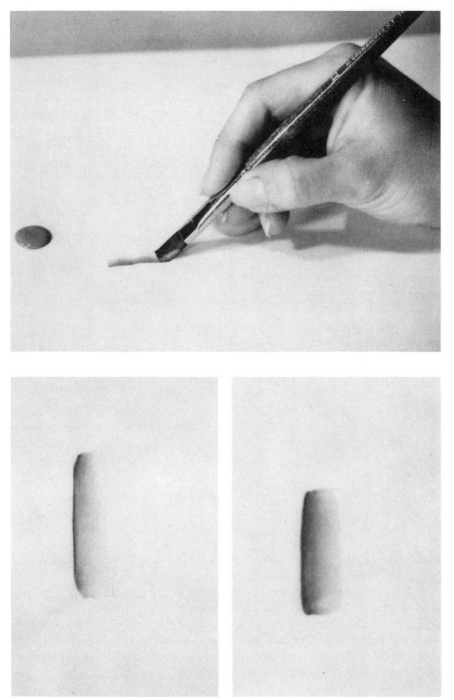

**Fig. 4-3**
Try the side-loaded step on your palette paper.

**Fig. 4-4** (Left)
A correctly loaded brush.

**Fig. 4-5** (Right)
This brush was incorrectly loaded with paint.

# WAVES AND CLOUDS

Side-loading techniques are used to form waves and clouds. Figure 4-6 shows the waves being formed using white paint on one side of the brush. The paint side faces up. The second row of waves is placed just under the first, allowing some space between the two.

**Fig. 4-6**
Waves are formed with a
side-loaded brush.

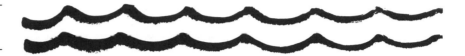

Clouds are formed by making circular motions with the side-loaded brush. Again side load the flat brush with white paint. Place the paint to the outside, and make several semicircular strokes in an uneven configuration (FIG. 4-7). Be creative with clouds. They should not all be uniform.

**Fig. 4-7**
Clouds should be uneven
and natural.

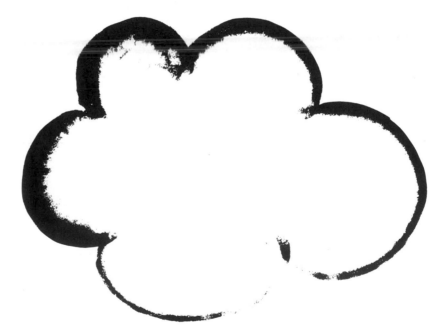

# RUFFLES AND LACE

Delicate lace designs also can be created using the technique of side loading. Follow the previous instructions for waves and clouds to form semicircular strokes with a flat brush side loaded in white paint. After forming

a row of strokes, use a liner brush to add lace lines in the center of the side-loaded strokes (FIG. 4-8), and then add various sizes of dots along the rounded edges (FIG. 4-9).

Lastly, if desired, paint in stitching lines near the base of the lace pattern (FIG. 4-10). Shading is usually done along the flat edge of the lace (FIG. 4-11).

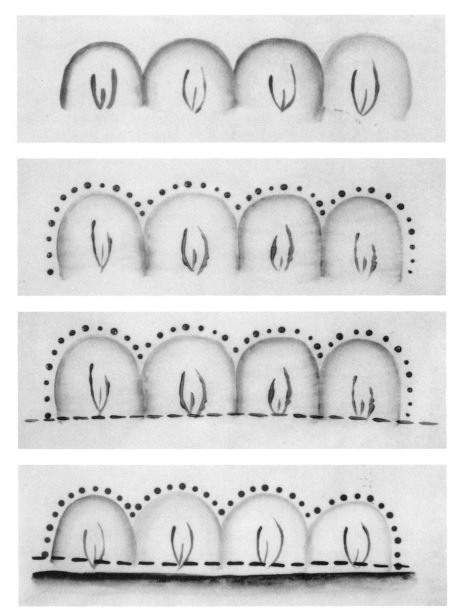

**Fig. 4-8**
Add lines to accent the folds in the lace.

**Fig. 4-9**
Dots help to enhance the finished look.

**Fig. 4-10**
Draw stitching lines with a liner brush if desired.

**Fig. 4-11**
With a side-loaded brush, shade under the lace for dimension.

# HIGHLIGHTING

In this book, *highlights* refer to the tiny comma strokes placed to enhance and spotlight areas in the painting. Most commonly, these are placed in eyes, on cheeks, on the rounded portion of a heart, and as a stroke inside a larger comma stroke.

# DECORATIVE FINISHES

Often the most striking look to your decorative piece is the use of a specialized finish. When choosing a technique, keep in mind that it should be compatible with the type of design you are painting. It should also coordinate with any other finishing style you are using.

Earlier in the book, I discussed the need for adding a finishing coat to your completed design. Various looks are available, so choose the one that goes best with your painting (FIG. 4-12).

**Fig. 4-12**
Choose whether you wish your finished work to have a matte, gloss, or satin look.

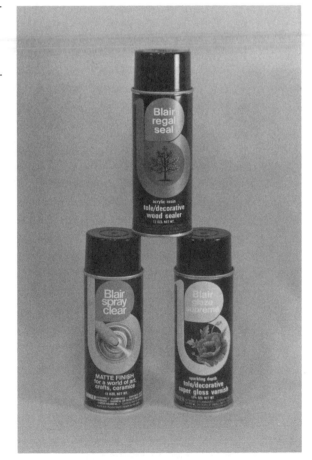

☐ *Gloss* finish is a very shiny, highly polished, glass-like look.

☐ *Matte* finishes are dull, with no shine to them. Many times, after application of the finish, the piece looks exactly the same as it did before application. It is still important to apply the finish to protect your work.

☐ *Satin* finishes are neither glossy nor dull. They provide a look that enhances the design, yet is subtle.

# ANTIQUING

The technique of antiquing is most often done after the piece is completely finished. When an antique finish is applied, the surface looks like it has been darkened with age.

Some commercially prepared antiquing mediums are available. If you purchase one, follow the manufacturer's instructions explicitly. In place of an antiquing medium, you can accomplish the same look with oil-based paints. You will need a tube of any color of oil paint (although *burnt umber* is the most commonly used). You should also have a can of turpentine and clean rags. (If the scent of turpentine bothers you, odorless varieties are available.)

Squeeze out a dime-sized area of oil paint. Wet a corner of the rag with turpentine and dab it into the paint. Rub the rag over the painted design, being sure to get it into all the nooks and crannies.

The paint should smoothly run over the design. If it is too thick and doesn't run smoothly, add more turpentine to the rag.

Take a clean area of the rag and slightly dampen it with clean turpentine. Wipe the design down, removing as much of the oil paint as desired. Wipe the finished piece down with a clean rag. Allow it to dry completely, then apply the finish of your choice.

# BASECOATING

Basecoating is an important technique to master. Your designs are basecoated immediately following the wood-sealing step. Basecoating can be done in an initial step only, or as a secondary step as well.

## Initial Basecoating

Initial basecoating refers to when you paint the entire piece for the first time. Usually when this is done, the entire piece or section of a piece is painted with the same color. Use the largest brush possible to cover the initial basecoating step. A 1-inch (2.5 cm) sponge brush works the best.

# Secondary Basecoating

The secondary basecoating technique is sometimes called *color book painting*. Its purpose is to solidly fill in certain areas of the design. No specific details are applied yet. After basecoating, the design will look lifeless and dull. The next techniques and brush strokes you add will bring the design to life.

# Hints for Basecoating

1. Use a sponge brush whenever possible to eliminate ridges. If your area is too small for a sponge brush, use the largest size brush available for the section you are basecoating. This creates fewer brush strokes.

2. Always use fresh, clean paint when basecoating. Never thin the paint. Use as it is dispensed from the bottle.

3. Avoid paint ridges by using two to three thin coats instead of one thick one. Brush strokes from the center of the design to the outside. Usually you should basecoat the back of the design to finish it off. Be as professional as possible with your work, and as neat as possible!

# SPECKLING

Many other names for the speckling technique exist, including *spattering*, *flecking*, and *flyspecking*. Basically, this method involves the application of fine specks of paint to your design. You can apply the specks to the background and then paint your design on top of them, or you can place the specks over the finished design.

Never apply speckling to a design that is not completely dry and finished. This way, if you do not like the way the speckling is turning out, you can wipe it off immediately with baby wipes—but only if your design was dry when you started.

Be sure to spread lots of newspaper around the area in which you are working. This technique is messy!

Mix your paint with water until it becomes the consistency of ink. Dip a clean, dry (old) toothbrush in the paint/water mixture. Gently rub your finger or a popsicle stick over the bristles which are aimed at your surface. This will emit tiny speckles of paint.

Before applying paint to your finished surface, try speckling on a paper towel. Several factors affect the final look, so if you practice first, you can adjust the output.

If the consistency of the paint is not thin enough, the specks of paint will be too heavy. If they are too thin, the paint will be nearly transparent. Adjust the ratio of paint to water if necessary.

The distance away from your object will greatly affect the look of the technique. A good distance is 6 inches (15 cm) to 12 inches (30.5 cm). The more pressure you apply to the paintbrush, the heavier the speckling will be. Decide how much of the technique you wish to show before you begin.

You can create the speckling look with more than one color of paint on an object. Wait for one color to dry before adding a second or third.

## COUNTRY SANDING

Country sanding is a technique that gives an old, well-worn look to the design. Choose the grade of sandpaper depending on the look you wish to create—courser sandpaper for a heavier look and finer paper for a delicate sanded finish.

After basecoating, simply rub the edges of the design with the sandpaper of your choice. Continue to sand the edges until you achieve the desired effect.

## SPONGE PAINTING

Using a sponge to add a textured look is an interesting effect to use in your decorative painting. Because this look is more pronounced than some of the others, it is best not to get too intricate with the painting you place on top of the sponge-painted technique.

First basecoat the surface, and let it dry completely. Then squeeze out a puddle of paint on the palette. Use a 2-inch (5 cm) sponge and dip gently into the puddle of paint. Dab the paint a few times on a scrap paper until you get the look you want, then begin to dab the sponge onto your decorative piece. The more you dabble the design, the softer the look will be.

Another factor that affects the harshness or subtlety of the look is the colors of paint you choose to use together. The closer together in shade and color the paints are, the softer your design will look. The further apart the paints are in shade and color, the harsher the look will be. You may use more than one shade of paint to sponge, but wait until one color dries completely before sponging with a second color.

≻ Part II ≺

# Painting Projects

# Animal Menagerie

*F*rom bunnies to carousel horses to, of course, the ever-popular teddy bears—I must admit, I love decorating with animals. These cute creatures can be used alone or placed into floral designs to add the finishing touch. If you are unable to find any of the wooden pieces shown in the projects here, simply trace the outside shapes and cut them out of wood yourself.

## BUNNY CAROUSEL

Soft, romantic colors give this carousel bunny a true Victorian feeling. He is perfect placed in either a formal or a country-looking room (FIG. 5-1).

You will need:

- [ ] 12-inch-tall (30.5 cm) × 8-inch-wide (20 cm) carousel bunny
- [ ] acrylic paint in the following colors: *deep rose, burgundy, eggshell, deep blue, black, pink*
- [ ] 1-inch (2.5 cm) sponge brush
- [ ] #10 flat brush
- [ ] #4 flat brush
- [ ] #2 round brush
- [ ] liner brush
- [ ] sealer and finish of your choice
- [ ] 1-ounce package dried gypsophila
- [ ] 2 yards (1.8 m) 1/8-inch-wide (.3 cm) eggshell satin ribbon
- [ ] 28-gauge cloth-covered wire
- [ ] adhesive of your choice

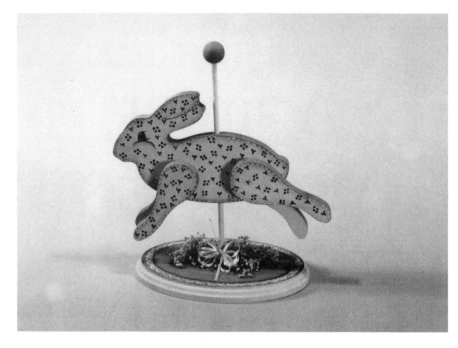

**Fig. 5-1**
The romantic colors of this cute carousel bunny give it a Victorian feeling.

1. Prepare the wood as explained in chapter 2.

2. Paint each area as follows: *pink*—entire bunny and outside edges of carousel base; *deep rose*—ball on top of carousel, edges of bunny, and top of carousel base; *eggshell*—carousel poles.

3. On top of the base, measure 1/2 inch (1.3 cm) in from the edge of the base. Using eggshell paint and following the instructions in chapter 4, paint gathered lace along the outside edge of the base.

4. Side-load the large flat brush with burgundy, and shade along the inside of the 1/2-inch (1.3 cm) mark.

5. Paint stitching lines 1/8 inch (.3 cm) around the outside edges of the bunny body, bunny legs, and bunny arms with eggshell.

6. Transfer and paint the bunny eyes black, following instructions for eyes in chapter 3 (FIG. 5-2).

7. Paint the remaining bunny with blue dots in a diamond shape and burgundy hearts formed with two comma strokes, side by side.

8. Assemble the carousel.

9. Glue clusters of baby's breath with 1-inch (2.5 cm) stems around the center carousel pole on the base.

10. Form two 1-yard (.9 cm) bows, secure with cloth-covered wire, and glue one on either side of the bunny.

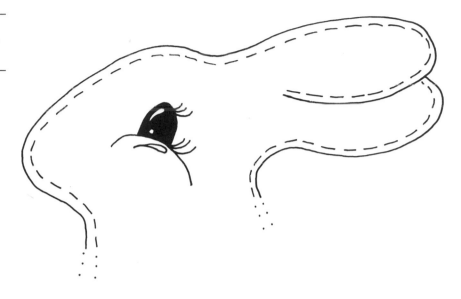

**Fig. 5-2**
Trace the eye of the bunny, but draw the stitching lines freehand.

# CHRISTMAS GOOSE

The techniques of country sanding and speckling are both used on this cheery Christmas goose design. I've added ribbon and Christmas greens to complete the overall look and feel (FIG. 5-3).

You will need:

- ☐ 16-inch-tall (40.5 cm) × 9-inch-wide (22.5 cm) wooden goose on pedestal
- ☐ acrylic paint in the following colors: *hunter green, white, deep red, black, golden yellow, dark brown*
- ☐ 1-inch (2.5 cm) sponge brush
- ☐ #8 flat brush
- ☐ #2 round brush
- ☐ liner brush
- ☐ sealer and finish of your choice
- ☐ 2 stems artificial pine with 8-inch (20 cm) pine portions
- ☐ 2 snowball pine picks with 3-inch (7.5 cm) pine portions
- ☐ 2 yards (1.8 cm) 1½-inch-wide (4 cm) red velvet ribbon
- ☐ 2 yards (1.8 cm) 7/8-inch-wide (2 cm) Christmas print ribbon
- ☐ red chenille stem
- ☐ sandpaper
- ☐ old toothbrush

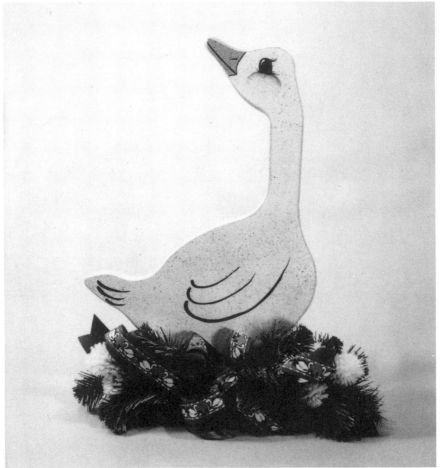

**Fig. 5-3**
This cheery goose is a
wonderful holiday
decoration.

1. Prepare the wood for painting as described in chapter 2.
2. Paint the base hunter green.
3. Paint the goose white. After it has dried, country-sand the edges.
4. Paint the lines on the tail and wing in deep brown.
5. Paint the beak golden yellow with the outline being black.
6. Transfer and paint the eye as shown in chapter 3, using deep red for the shading on the cheek (FIG. 5-4).
7. Use brown paint to speckle the entire goose as explained in chapter 4.
8. Seal the finished piece following the manufacturer's instructions.
9. Attach the goose to the base.

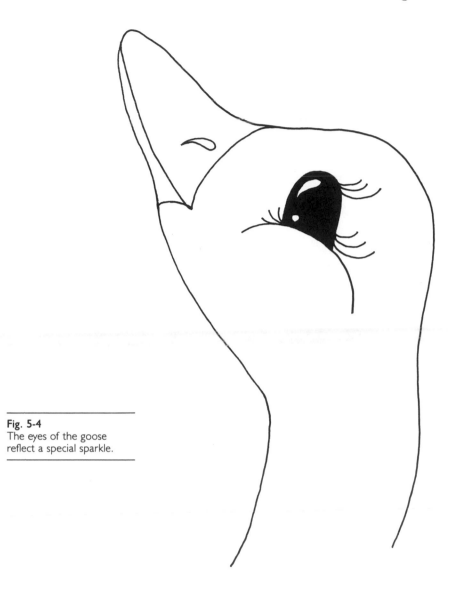

**Fig. 5-4**
The eyes of the goose
reflect a special sparkle.

10. Cut the stems of the pine to 2-inch (5 cm) lengths, and glue them end-to-end in front of the goose.

11. Place the snowball pine on top of and inside the stems of the green pine.

12. Form a bow with the print ribbon placed on top of the velvet ribbon. The bow should have 9-inch (22.5 cm) streamers and six or eight 3-inch (7.5 cm) loops. Glue the bow over the stem ends of the pine.

# DUCK WALL RACK

It is sometimes difficult to find designs suitable for the "masculine" portions of the home, but this duck wall rack is just right for such areas. This design will be spectacular if placed in a hall or den (FIG. 5-5).

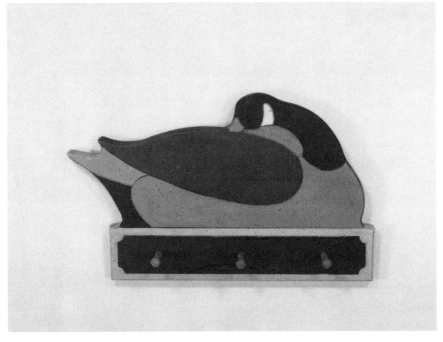

**Fig. 5-5**
Deep rich tones suggest a masculine feeling.

You will need:

☐ 14-inch-wide (35 cm) × 9-inch-tall (22.5 cm) carved wall rack

☐ burnt umber oil-based paint

☐ acrylic paint in the following colors: *turquoise, navy blue, brown, dark avocado green, light avocado green, gray, hunter green, rust, copper*

☐ brushes: #6 flat, #4 flat, and #10 flat

☐ sealer and finish of your choice

☐ rags

1. Prepare the wood as described in chapter 2.
2. The wood plaque used here was pre-carved, so you need only fill in the carved spaces with color. Using the brushes of your choice, paint each area as follows: *rust*—beak; *navy blue*—head, neck, and lower tailfeathers; *copper*—neck decoration; *dark avocado*—body; *brown*—wing; *gray*—upper tailfeathers and pegs; *hunter green*—base center;

*light avocado*—base frame; *turquoise*—area between feathers and neck.

3. Follow the instructions in chapter 4 to antique the entire duck with the oil paint.

4. Use the brown paint, and follow the instructions in chapter 4 to add speckling to the finished piece.

5. Seal the duck following package directions.

# CHICKENS

The calico designs on the comb and tail of these chickens make the pieces especially striking in color and design. Shading the main portion of the body creates dimensions (FIG. 5-6).

**Fig. 5-6**
The calico designs give these chickens a country feeling.

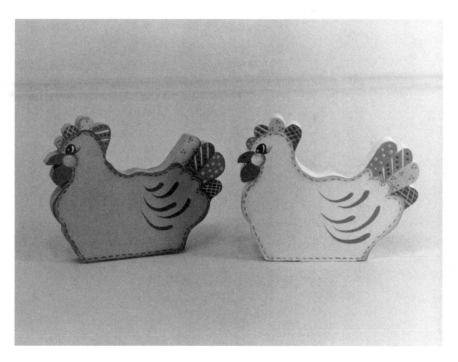

You will need:

- ☐ 25<sup>1</sup>/2-inch-wide (64.3) wide × 4<sup>1</sup>/2-inch-tall (11.3) cutout chickens
- ☐ acrylic paint in the following colors: *eggshell, tan, golden yellow, rust, brown, black*
- ☐ 1-inch (2.5 cm) sponge brush
- ☐ #4 round brush
- ☐ #2 round brush

☐ liner brush

☐ sealer and finish of your choice

1. Prepare the wood as described in chapter 2.

2. Basecoat one entire chicken eggshell and the other tan.

3. When the pieces are dry, transfer the main lines for the chicken and the chicken facial features (FIG. 5-7).

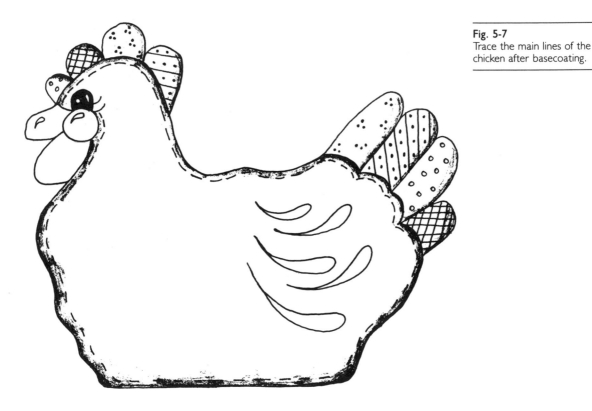

**Fig. 5-7**
Trace the main lines of the chicken after basecoating.

4. Paint the four calico patterns on the tail and comb of each of the chickens (FIGS. 5-8 through 5-11).

Pattern #1 (FIG. 5-8): Paint the background *tan* and the dots *golden yellow*.

Pattern #2 (FIG. 5-9): Paint the background *rust*, the dots *brown*, and the lines *eggshell*.

Pattern #3 (FIG. 5-10): Paint the background *golden yellow*, and the dots *tan*.

Pattern #4 (FIG. 5-11): Paint the background *brown* and the lines *golden yellow*.

**Fig. 5-8** (Top Left)
Calico pattern #1.

**Fig. 5-9** (Top Right)
Calico pattern #2.

**Fig. 5-10** (Bottom Left)
Calico pattern #3.

**Fig. 5-11** (Bottom Right)
Calico pattern #4.

5. Paint the facial features on each chicken the same. Paint the eye black with eggshell highlights. For the cheek, use a flat brush side loaded with rust and shaded in circle; highlight is eggshell. For the beak and wattle, use rust with black highlights.

6. Side load the flat brush with brown and shade the tan chicken body as shown in (FIG. 5-7).

7. Side load the brush with tan and shade the eggshell chicken body.

8. Add brown stitching lines and comma stroke feathers to the body of the tan chicken.

9. Add tan stitching lines and comma stroke feathers to the body of the eggshell chicken.

10. Side load a flat brush with brown, and shade the right side of each of the calico sections in the tail and comb of both birds.

11. Seal the chickens following instructions on the product you have chosen.

# GOOSE NAPKIN HOLDERS

The center cutout of these geese allow versatility of use. In addition to being decorative additions, they can double as napkin rings (FIG. 5-12).

## Tall Goose

You will need:

☐ 6½-inch-tall (16.3 cm) × 2¼-inch-wide (5.6 cm) wooden goose

☐ acrylic paint in the following colors: *white, tan, rust, pink, deep pink, black*

☐ brushes: #10 flat, #4 flat, #2 flat, liner brush

☐ sealer and finish of your choice

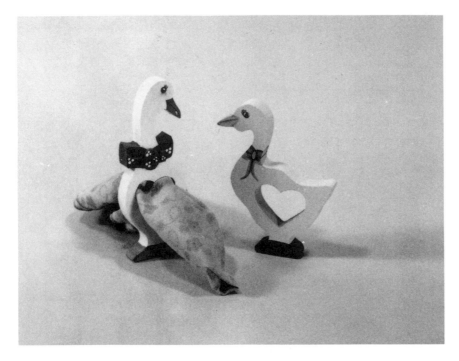

**Fig. 5-12**
These delightful geese can double as napkin rings.

1. Prepare the wood as explained in chapter 2.
2. Basecoat the entire piece with white paint.
3. Transfer the beak, eye, bow, and feet lines (FIG. 5-13).
4. Paint beak and feet tan, then side load the flat brush with rust and shade around the lines. Draw rust lines down the center of the beak.
5. Paint the eye black, and shade the left side with white. Then add white dot to highlight.
6. Paint inside of heart and entire bow pink. Use deep pink on side-loaded flat brush to shade bow.
7. Seal the finished piece following package instructions.

# Fat Goose

You will need:

- ☐ 3/4-inch-wide (9.3 cm) × 5¹/₂-inch-tall (13.8 cm) goose
- ☐ acrylic paint in the following colors: *pink, light blue, dark blue, brown, black, white, golden yellow, tan*
- ☐ sealer and finish of your choice
- ☐ brushes: #10 flat, #4 flat, #4 round, #2 round, liner brush

**Fig. 5-13**
Trace the main lines after
basecoating.

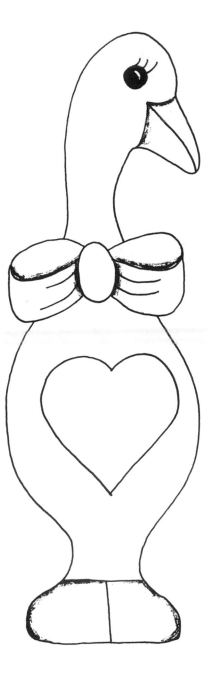

1. Prepare the wood for painting as described in chapter 2.
2. Basecoat the entire piece pink.
3. Transfer the lines of the goose (FIG. 5-14).

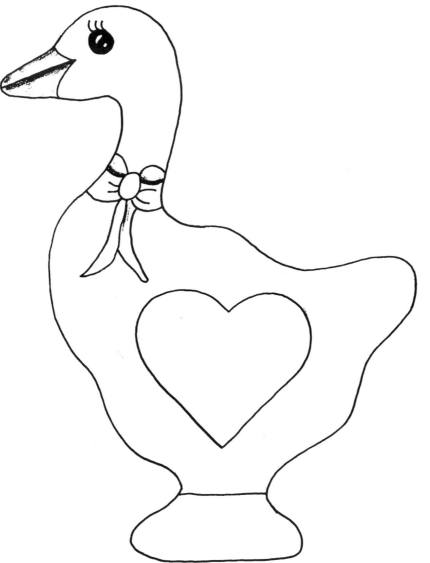

**Fig. 5-14**
Geese can be tall or fat.

4. Paint the feet brown.

5. Paint the beak yellow and shade it with tan.

6. Paint the eye black, shade the right side with white, and draw the highlights with white.

7. Paint the inside of the heart and bow light blue. Shade the bow with dark blue.

8. Complete the piece by applying the finish of your choice.

# TEDDY BEARS

Bears seem to be everyone's all-time favorite animal. This book would not be complete without including at least one. But you're in luck, I've included two! Although both bears were painted using the same form, you can see how different they look—one being painted as a panda and the other as a brown bear (FIG. 5-15).

**Fig. 5-15**
Everyone loves bears!

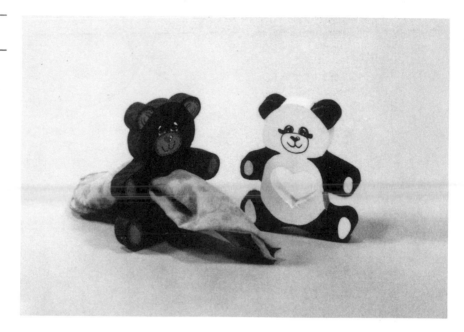

# Panda

You will need:

- □ 4¹⁄₄-inch-wide (10.6 cm) × 5-inch-tall (12.5 cm) bear shape with or without heart cutout
- □ white acrylic paint
- □ black acrylic paint
- □ brushes: #10 flat, #6 flat, #4 flat, #4 round, #2 round, liner brush
- □ sealer and finish of your choice

1. Prepare the wood as described in chapter 2.
2. Paint the ears, arms, and legs black.
3. Paint the stomach and head white.
4. Transfer the main lines in (FIG. 5-16).
5. Paint all the darkened areas of the facial features black.

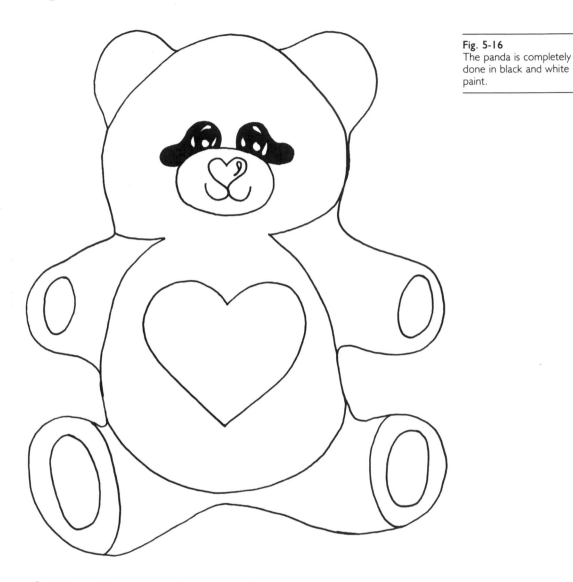

**Fig. 5-16**
The panda is completely
done in black and white
paint.

6. Paint white ovals on the arms and legs.

7. Shade the edges of the ears and the lines between the paws, arms, and legs white.

8. Seal the finished bear.

## Brown Bear

You will need:

☐ 4¹/4-inch-wide (10.6 cm) × 5-inch-tall (12.5 cm) bear shape with or without heart cutout

☐ acrylic paint in the following colors: *brown, tan, rust, black, white, red*

☐ brushes: #10 flat, #6 flat, #4 flat, #4 round, #2 round, liner brush

☐ sealer and finish of your choice

1. Prepare the wood, following instructions in chapter 2.

2. Paint the entire bear brown.

3. Transfer the main lines in (FIG. 5-17).

4. Paint the inside of the ears, ovals on the paws, muzzle, and inside of the heart tan.

**Fig. 5-17**
More stitching lines on the brown bear give it a different feeling.

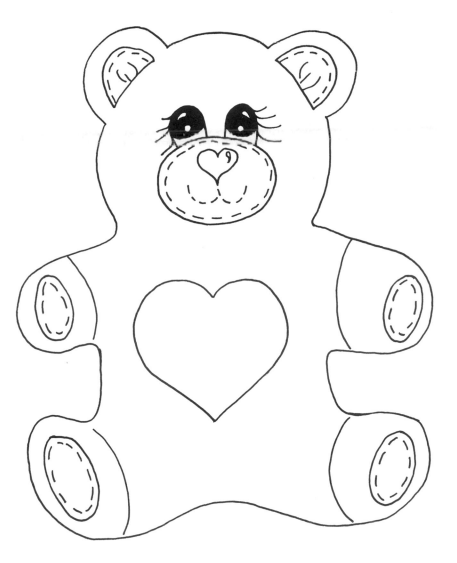

5. Shade inside of all the pieces in #4 flat brush side loaded with rust paint. When dry, draw stitching lines and lines inside of ear with rust paint.

6. Paint mouth stitching lines black.

7. The nose is red with a white highlight.

8. The darkened areas of the eye should be painted black; the highlight and lower portion of the eyes are white.

9. Side load the brush with black paint, and shade between the paws, arms, and legs.

10. Seal the finished piece.

# ROCKING HORSE

This miniature rocking horse is a perfect piece to attach to one of the wooden toy bases, or simply use it as a decorative accent (FIG. 5-18).

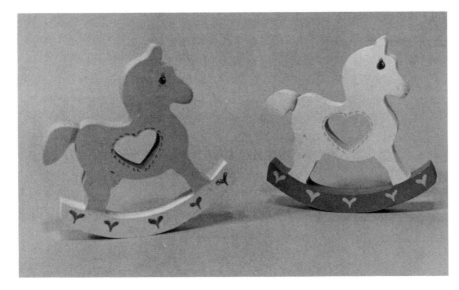

**Fig. 5-18**
A mini rocking horse can be used alone or added into a design.

You will need:

☐ 5-inch (12.5 cm) × 5-inch (12.5 cm) wooden rocking horses
☐ acrylic paint in the following colors: *white, rust, pink, black*
☐ Brushes: #10 flat, #4 flat, #4 round, #2 round, liner brush
☐ sealer and finish of your choice

1. Prepare the wood as explained in chapter 2.

2. Basecoat the entire piece white.

3. Transfer the eye design, paint it black, and highlight with white (FIG. 5-19).

4. Paint the rocker portion rust.

5. Paint two comma strokes side by side with round brush to form the hearts on the rocker.

**Fig. 5-19**
If you are unable to find a cutout rocking horse, simply trace-cut your own from wood.

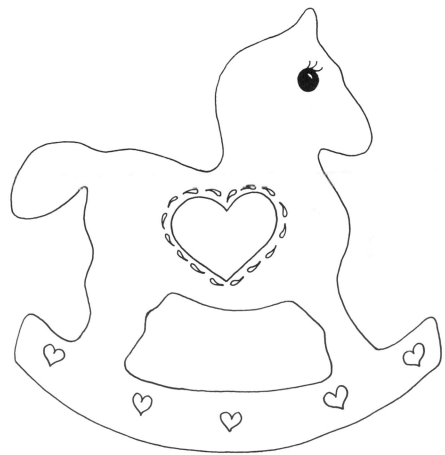

6. Shade the nose and tail with a flat brush side loaded with rust paint.

7. Paint the inside of the heart pink, and place tiny comma strokes around the heart which are also pink.

8. Seal the horse when the paint has dried.

# WELCOME SHEEP

This fluffy fellow says, "Welcome to our home." It's a lovely piece to hang on a front door; if properly sealed for outdoor use, or when the door is placed under an overhang (FIG. 5-20).

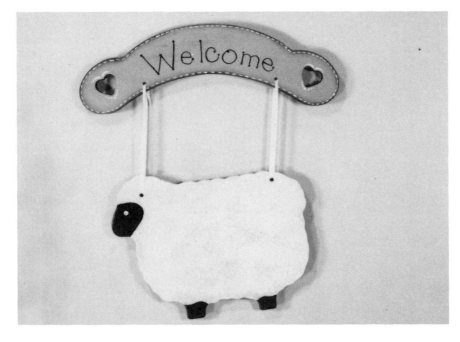

**Fig. 5-20**
This design says, "Welcome to our home!"

You will need:

☐ Sheep welcome set: *Sheep*—10¹/₂-inch-wide (27 cm) × 8¹/₂-inch-tall (21.3 cm), *Welcome board*—14 inch-wide (35 cm) × 2¹/₂-inch-tall (6.5 cm)

☐ acrylic paint in the following colors: *gray, white, blue, light green, dark green*

☐ 1-inch (2.5 cm) sponge brush

☐ brushes: #10 flat, #6 flat, #4 round, #2 round, liner brush

☐ sealer and finish of your choice

☐ 2-inch (5 cm) household sponges

1. Prepare the wood according to instructions in chapter 2.
2. Paint the entire sheep gray.
3. Following instructions in chapter 4, sponge-paint the sheep body with white paint.
4. Transfer the face and draw in feet—paint these black (FIG. 5-21).

**Fig. 5-2l**
Trace the sheep's face onto the wood after applying the sponge technique to the body.

5. Paint in a white circle for the eye with a tiny black dot for the eyeball.

6. Shade the front sides of both feet with a side-loaded brush of white paint.

7. Paint the entire header light green.

8. Paint the outside edge dark green. Then side load the large flat brush with dark green, and shade along edges of front of plaque.

9. Draw stitching lines with white paint. Add commas and dots above and below the heart with white paint.

10. Paint ''Welcome'' following the alphabet in chapter 4, using black paint.

11. Seal the finished design. If you plan to use it outdoors, be sure your finish is made for this application.

# DOG BONE BOX

This box is a decorative way to display dog bones or other treats for your pet. The sponge-painted technique is a perfect accent for this piece (FIG. 5-22).

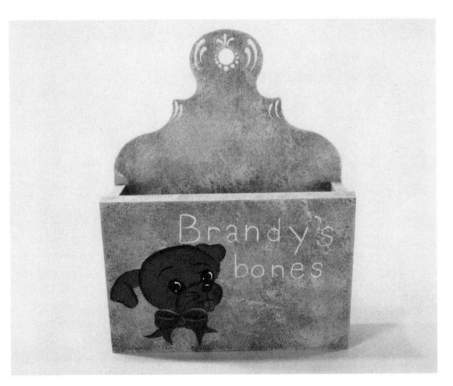

**Fig. 5-22**
The dog bone box provides a decorative way to hold treats for your favorite pet.

You will need:

- ☐ 9-inch-wide (22.5 cm) × 2-inch-tall (5 cm) × 5-inch-deep (12.5 cm) wall box
- ☐ acrylic paint in the following colors: *light blue, medium blue, dark blue, eggshell, tan, brown, black, red*
- ☐ 1-inch (2.5 cm) sponge brush
- ☐ brushes: #10 flat, #6 flat, #4 flat, #6 round, #4 round, #2 round, liner brush
- ☐ 2-inch (5 cm) squares household sponges
- ☐ sealer and finish of your choice

1. Prepare the wood for painting as described in chapter 2.
2. Basecoat the entire piece with medium blue paint.

3. Follow instructions in chapter 5, and sponge-paint the entire box first with light blue paint and then with tan paint.

4. Transfer the dog design to the left side of the box front (FIG. 5-23).

**Fig. 5-23**
Trace the dog face to the left side of the front of the box.

5. Paint the dog brown and shade around the head, ears, and muzzle with black.

6. The eyebrows are black comma strokes.

7. Paint the tongue red.

8. Paint the eyes, nose, and mouth lines black.

9. Highlight the eyes and nose with eggshell.

10. Whiskers are black dots with stroke lines of black.

11. Paint the bow medium blue, and shade with dark blue.

12. Draw the name with eggshell paint using the alphabet in chapter 4.

13. Add commas and dots of eggshell paint around the top of the box (FIG. 5-24).

**Fig. 5-24**
Add decorative
embellishments to finish the
top of the box design.

# CAROUSEL HORSE

This striking design has a feeling of elegance, perhaps because the lines are clear and crisp with highlights of metallic gold (FIG. 5-25).

You will need:

- [ ] 22-inch-tall (55.5 cm) × 15-inch-wide (38 cm) wooden carousel horse
- [ ] acrylic paint in the following colors: *eggshell, brown, deep rose, black, celedon green, metallic gold, peach*
- [ ] sealer and finish of your choice
- [ ] 1-inch (2.5 cm) sponge brush
- [ ] brushes: #8 flat, #10 flat, #4 flat, #2 flat, #8 round, #4 round, #2 round, liner brush

1. Prepare the wood according to instruction in chapter 2.
2. Paint the carousel pole and ball metallic gold.
3. Paint the top of the base peach. Sides of the base should have one stripe of metallic gold with the remainder of the side being deep rose.
4. Transfer the pattern in (FIG. 5-26), then paint hearts metallic gold, commas green, and dots deep rose.
5. Paint entire horse eggshell.
6. Transfer: head and front design (FIG. 5-27), saddle (FIG. 5-28), tail and rear design (FIG. 5-29). The front and rear embellishments should mostly be painted freehand.

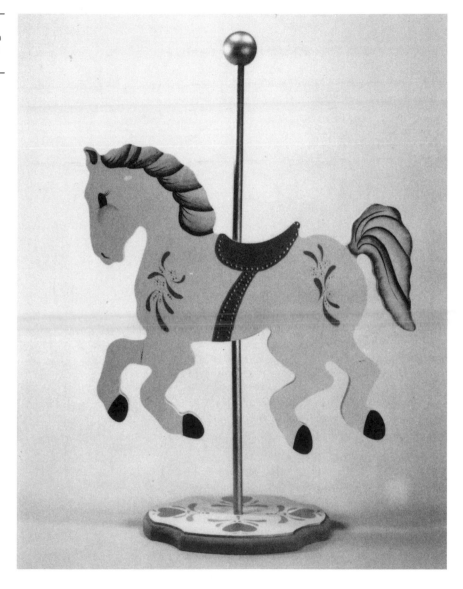

7. Paint the horses hooves black.

8. The mane and tail are shaded with a large flat brush side loaded with brown paint. After drying, add lines of dark brown to accent.

9. The eye is black with eggshell highlights. The shaded cheek is done with a side-loaded brush of deep rose. The nostril is a black comma stroke.

10. Paint the saddle deep rose with outlines of green and dots of metallic gold.

*59*

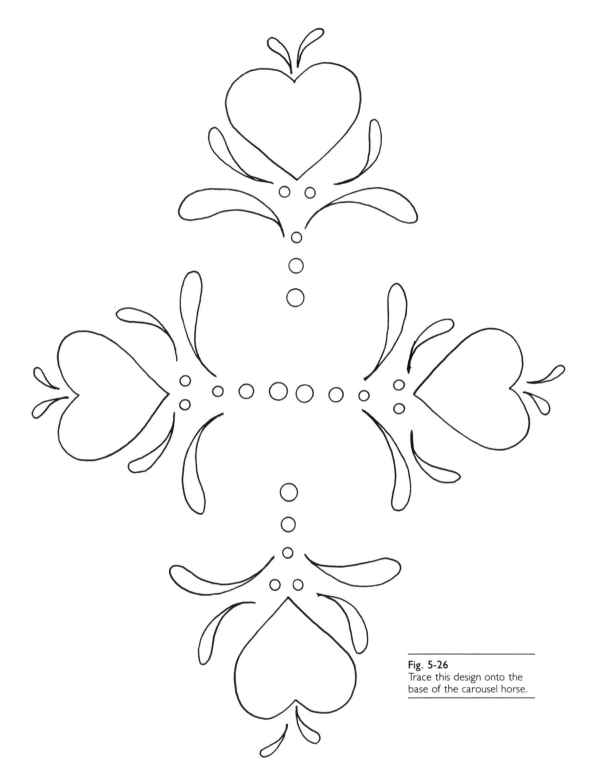

**Fig. 5-26**
Trace this design onto the
base of the carousel horse.

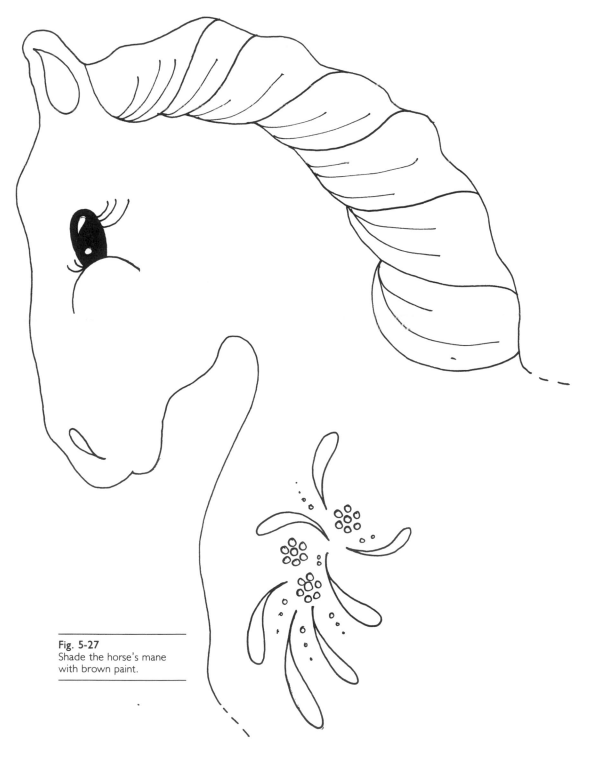

**Fig. 5-27**
Shade the horse's mane
with brown paint.

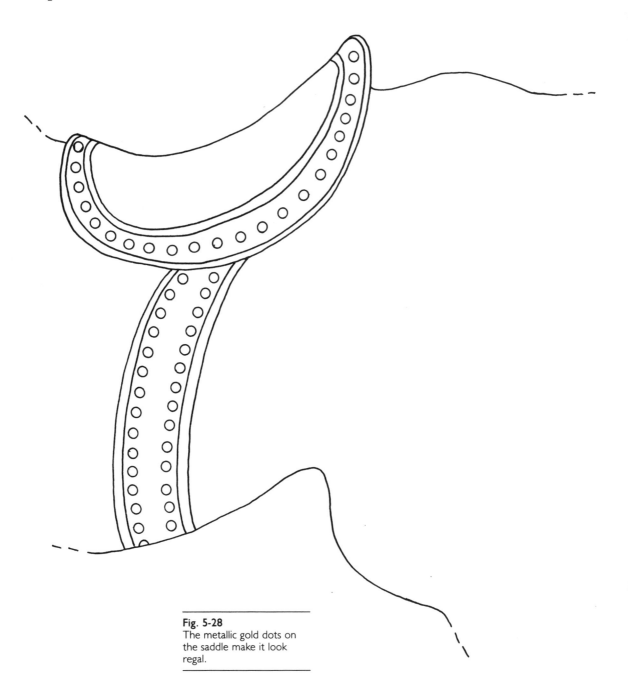

**Fig. 5-28**
The metallic gold dots on
the saddle make it look
regal.

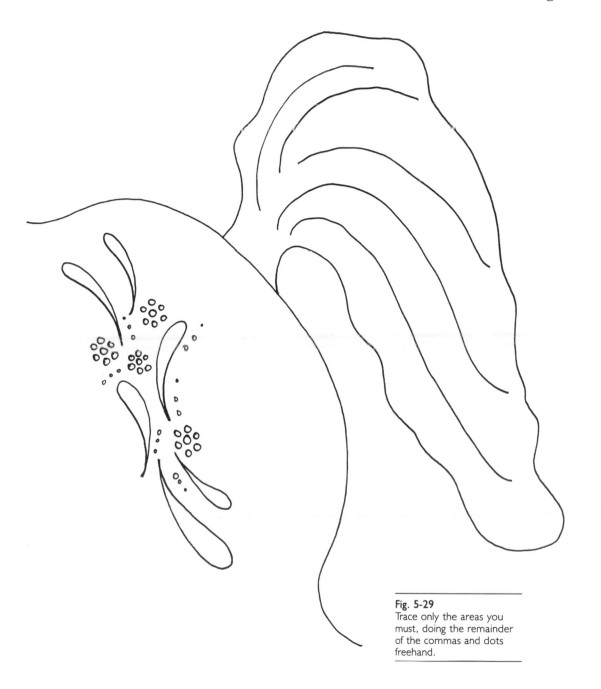

**Fig. 5-29**
Trace only the areas you
must, doing the remainder
of the commas and dots
freehand.

11. Paint the designs with commas of green, flowers of peach, and dots of metallic gold.

12. Seal the entire completed design following manufacturers instructions.

# DIMENSIONAL GEESE

Decorative painting can take on a special touch when you dimensionalize your artwork. Rather than merely painting these cheery fellows, make them look fuzzy and soft—just like geese should! This technique can be applied to any animal of your choice in place of flat basecoating (FIG. 5-30).

**Fig. 5-30**
A special treatment gives depth and dimension to these geese.

You will need:

☐ 14-inch-wide (35 cm) × 9-inch-tall (22.5 cm) double wooden geese with heart

☐ red acrylic paint

☐ brown acrylic paint

☐ tan acrylic paint

☐ large flat brush

☐ four ¹/₂-inch-wide (1.3 cm) moveable eyes

☐ sealer and finish of your choice

☐ two disposable diapers or polyester stuffing material that doesn't contain acrylic fibers

☐ fabric stiffener

☐ two 2-inch Styrofoam eggs

☐ two 3/4-inch Styrofoam balls

☐ adhesive of your choice

☐ toothpicks

1. Prepare the wood as explained in chapter 2.

2. Paint beaks and feet brown and heart red.

3. Cut the Styrofoam balls and eggs in half, and glue half of the 3/4-inch (1.8 cm) ball on each goose cheek and half of the 2-inch (5 cm) eggs in the center of the body for wings. The larger part of the egg should face forward.

4. Take off the plastic outer wrapping of the diapers and finely shred the inside material.

5. Mix the tan paint with the fabric stiffener approximately 1 part paint to 4 parts fabric stiffener. Add more paint for darker coloring.

6. Dip the shredded diaper into the fabric stiffener mixture until just coated and soaked through, but not dripping wet.

7. Use the toothpicks to lay the material in place, completely covering the geese.

8. Allow to dry approximately 24 hours before turning over and doing the other side.

9. Glue the moveable eyes in place.

# Projects for Kids

$C$hildren often can be the center of our lives; we therefore enjoy creating special treasures just for them. When designing painted pieces, it is nice to create a group that will stand out in the decor of the room. Although all of these designs can be painted and enjoyed individually, notice how smashing they look in a group. The rule for children is to use bright, perky, cheerful colors. Most of all, enjoy yourself; the kids are sure to love your designs.

## ~ NAUTICAL ~

Children love gifts! They especially love handmade ones. Although I've used these designs to decorate four projects for a little boy's room, remember that you can use these same designs in similar or different colors to decorate other home-decor pieces.

## PICTURE FRAME

School pictures need a place of honor to be displayed. What better place than in this cute nautical frame? (FIG. 6-1).

You will need:

☐  9$\frac{1}{2}$-inch-wide (23.8 cm) × 11$\frac{1}{2}$-inch-tall (29.3 cm) wooden photo frame.

☐  walnut oil-based stain

☐  acrylic paint in the following colors: *white, red, medium blue, navy blue*.

☐  #2 round brush

☐  #4 flat brush

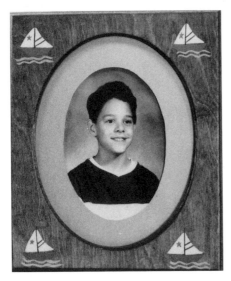

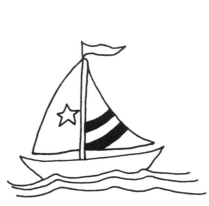

**Fig. 6-1** (Left)
A nautical theme used to decorate a picture frame is just one of the many pieces in this collection.

**Fig. 6-2** (Right)
Transfer this sailboat to the four corners of the picture.

☐ rags

☐ sealer and finish of your choice

1. Prepare the wood as described in chapter 2.

2. Stain the frame with walnut stain, following the manufacturer's instructions.

3. Trace the sailboat from FIG. 6-2 into four corners of the frame.

4. Paint the various parts of the sailboat as follows: *white*—sails; *red*—stars and flag; *navy blue*—stripes; *medium blue*—waves.

5. Apply the finish of your choice, following the manufacturer's instructions.

# WALL RACK

Little boys always have something to hang—from hats to mitts to belts. This project is the perfect one to fill that need (FIG. 6-3).

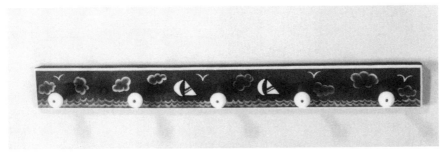

**Fig. 6-3**
Any boy will love having this nautical wall rack adorning his wall.

You will need:

- ☐ 22-inch-long (55.5 cm) × 2¹/₂-inch-wide (6.5 cm) wall rack with 5 pegs
- ☐ acrylic paint in the following colors: *medium blue, brown, red, black, white*
- ☐ #8 flat brush
- ☐ 1-inch (2.5 cm) sponge brush
- ☐ #2 round brush
- ☐ liner brush
- ☐ sealer and finish of your choice

1. Prepare the wood for painting as explained in chapter 2.
2. Paint the entire top of the wall rack blue.
3. Paint the ends of the pegs white and the remainder of the pegs red, with a red dot in the center of the peg.
4. Paint one stripe of white around the rack base and one stripe of red around the base.
5. Side load the large flat brush with white paint as shown in chapter 4, and form two rows of waves along the bottom of the wall rack base.
6. Transfer the sailboat from FIG. 6-4 twice to the center of the wall rack. Paint each area as follows: *white*—sail; *red*—stripes and flag; *brown*—center pole and boat; *black*—all outlines.
7. Place birds and clouds randomly through the sky. To form the birds, simply make two liner-brush strokes in an exaggerated V shape.

**Fig. 6-4**
Trace two of these boats to the center of the wall rack.

## TREASURE BOX

Boys love to collect things. Regardless of what the item is, it is considered a treasure, so a treasure box will be much appreciated (FIG. 6-5).

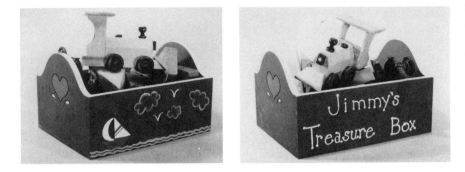

**Fig. 6-5**
Treasure boxes hold many special mementos.

You will need:

☐ 12 1/2-inch-long (31.8 cm) × 9 1/2-inch-wide (23.8 cm) × 7 1/2-inch-tall (18.8 cm) open-topped wooden box.

☐ acrylic paint in the following colors: *red, white, medium blue, brown*.

☐ sealer and finish of your choice

☐ 1-inch (2.5 cm) sponge brush

☐ brushes: #10 flat, #4 flat, #6 round, #2 round

1. Prepare the wood as described in chapter 2.

2. Paint the entire inside of the box red, and paint the outside and edges white. The pictured box was purchased with a heart and comma strokes carved on the side. To accent these, I painted the heart red and the commas white.

3. Using red paint and the alphabet in chapter 4, personalize one side of the box.

4. With the #4 flat brush, paint two rows of waves along the base of the other side of the box.

5. Transfer the sailboat in FIG. 6-6 to the left side of the box on top of the waves. Paint the sail in *white*; the stripes, flag, boat in *red*; and the flag pole in *brown*.

6. Form clouds by side loading large flat brush with white paint as shown in chapter 3.

7. Form two birds with the small round brush starting at the base of the V and pulling two strokes upward.

8. Apply the sealer of your choice according to manufacturer's instructions.

*The new baby will love these bright nursery designs, rich in color and feeling.*

*Colors and patterns are used to create dazzling Easter eggs.*

*When designing several home decor pieces, coordinate their colors to create a feeling of unity in the room.*

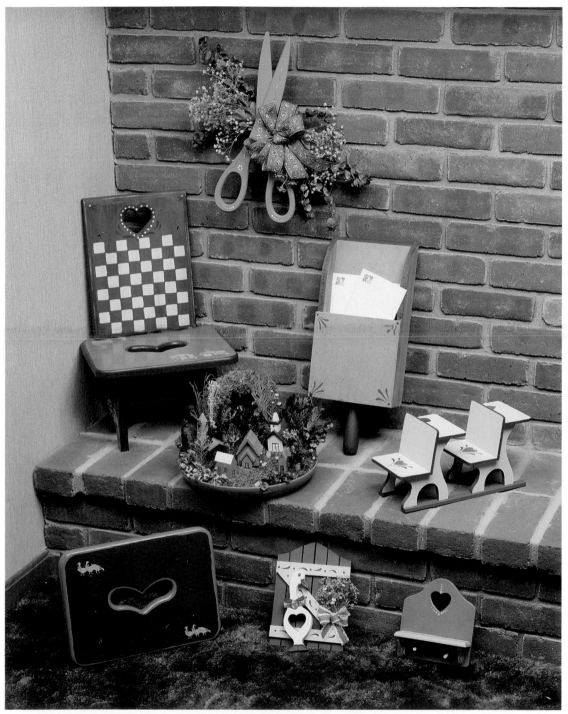

*Deep, rich color tones create a warm feeling. Match the colors of your decorative pieces to the surroundings they will inhabit.*

*Ruffles and lace are lovely accents used in coordination with flowers and comma-stroke leaves.*

*Use an old toothbrush, your finger, thinned-down paint, and lots of newspapers for the speckling technique.*

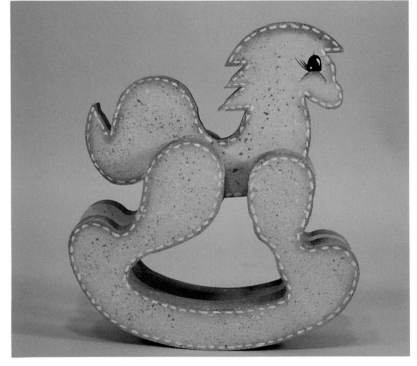

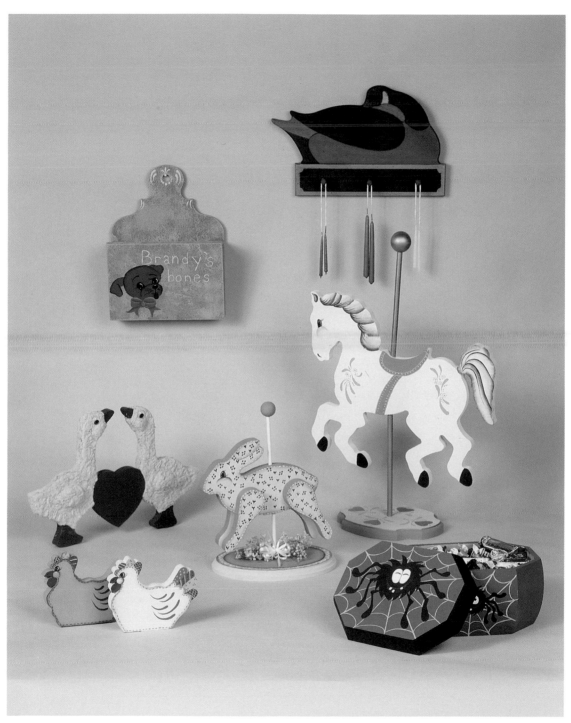

*Painting animal figures are fun, and they often become the focus of the room they decorate.*

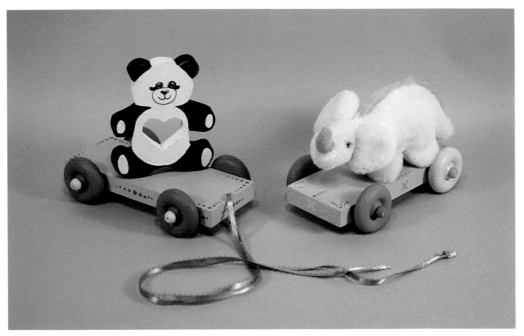

*You'll find patterns in this book for several pull toy variations, including a panda bear and a dinosaur.*

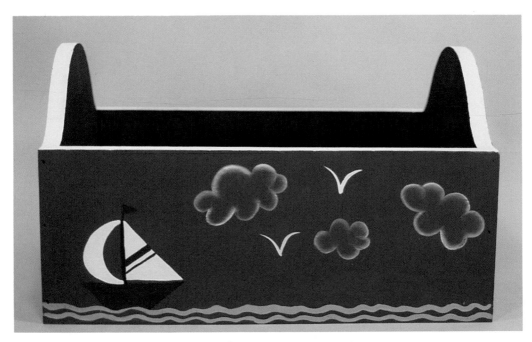

*Clouds are formed by side-loading a large, flat brush with white paint and forming uneven semicircles of color.*

*Holidays and special gifts are very important reasons to paint. Begin an heirloom today!*

*A little boy will love this special nautical grouping designed just for him.*

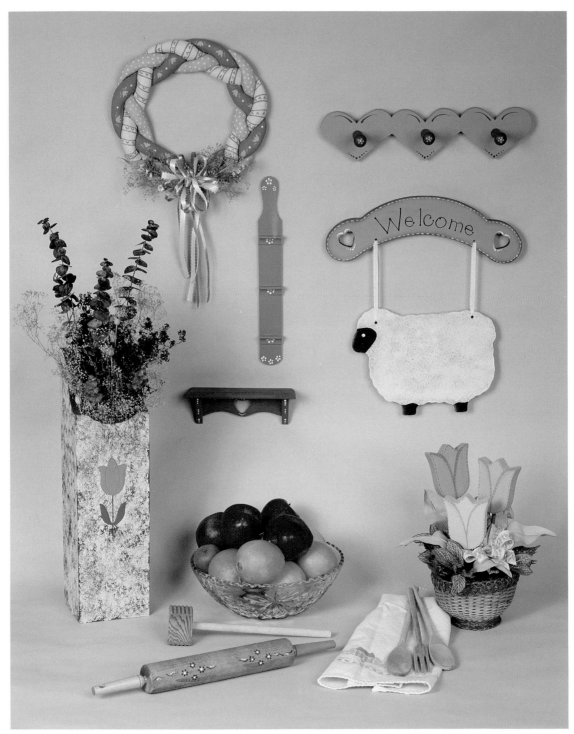

*A few simple techniques can be used together over and over to create exciting new designs.*

**Fig. 6-6**
A larger sized sailboat is
used to decorate the
treasure box.

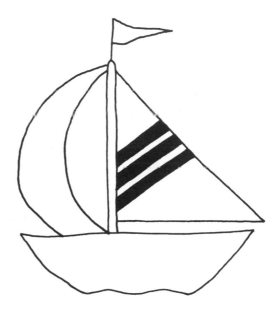

# BLOCKS AND PULL TOY

Children love to see their names used over and over and over again. With
these blocks, you can reinforce the name on the treasure box—sure to
please any youngster (FIG. 6-7).

You will need:

☐  1³/₄-inch (4.3 cm) square blocks (1 per letter of name)

☐  7³/₄-inch-long (19.3 cm) × 4-inch-wide (10 cm) pull toy base

**Fig. 6-7**
To complete the nautical
collection, this pull toy is
smashing.

- □ acrylic paint in the following colors: *medium blue, pale blue, dark blue, white, red, brown*
- □ 1-inch (2.5 cm) sponge brush
- □ liner brush
- □ #2 round brush
- □ sealer and finish of your choice
- □ 1 yard (.9 cm) of ¼-inch-wide (.6 cm) blue scallop-edged ribbon

# Blocks

1. Paint entire block dark blue.
2. Form rope around block front by forming white dots close together and painting S shapes between with a liner brush as shown in FIG. 6-8.
3. Print letters of child's name following instructions in chapter 4.
4. Apply your choice of finish to the blocks.

**Fig. 6-8**
Paint tiny dots, surrounding them with elongated ''s's'' to form a rope.

# Pull Toys

Our pull toys have been created in a number of styles and painted in many different color themes. Choose the one that is best for you or simply create your own!

1. Paint entire base medium blue.
2. Paint two wheels light blue and two wheels dark blue. Paint the centers of the light blue wheels dark blue; and the centers of the dark blue wheels light blue. Add tiny dots of white in the wheel center.

**Fig. 6-9**
(Left) Side of pull-toy design; (Right) Top corners of pull-toy design.

3. Follow the diagram in FIG. 6-9 to paint designs on the pull toy. Around the sides, the commas are white and the dots are dark blue. On top, the commas are dark blue and the dots are white.

4. Apply your choice of finish to the pull toy.

# Christmas Pull Toy Variation

You will need:

☐ 7³/4-inch-long (19.3 cm) × 4-inch-wide (10 cm) pull toy base
☐ red acrylic paint
☐ green acrylic paint
☐ metallic gold acrylic paint
☐ sealer and finish of your choice
☐ 1-inch (2.5 cm) sponge brush
☐ #2 round brush
☐ decorations of your choice, we used:
  ~ 5-inch-tall (12.5 cm) white sitting Santa bear
  ~ four 1¹/4-inch-wide (3.1 cm) wooden blocks
  ~ 2 yards (1.8 cm) ¹/4-inch-wide (.6 cm) red scallop-edged satin ribbon
☐ hot glue gun or Crafter's Cement

1. Prepare the toy base as described in chapter 2.
2. Paint the entire toy base with green paint.
3. Paint the wheels of the pull toy red.
4. Paint the centers of the wheels metallic gold.
5. Paint red comma strokes and gold dots as shown in FIGS. 6-10A and 6-10B.
6. Attach the ribbon through the hole in the pull toy and tie knots in the ends (FIG. 6-11).
7. Glue the decorations to the top of the toy base.

**Fig. 6-10A**
Side design on Christmas pull toy.

**Fig. 6-10B**
Top design on Christmas pull toy.

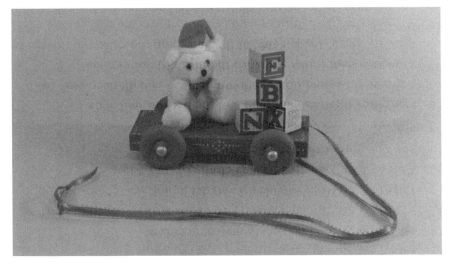

**Fig. 6-11**
Finished Christmas pull toy.

## MORE PULL TOYS

Here are two more pull toy designs (FIG. 6-12) that are sure to delight any youngster.

## Lavender Pull Toy

You will need:

☐   wooden pull toy base

**Fig. 6-12**
Create many more styles of pull toys. Your imagination is the only limit!

- [ ] lavender acrylic paint
- [ ] deep purple acrylic paint

1. Paint entire base and centers of wheels lavender.
2. Paint remainder of wheels and dots on toy deep lavender.

## Pastel Pull Toy

You will need:

- [ ] wooden pull toy base
- [ ] acrylic paint in the following colors: *pale yellow*, *pale pink*, *aqua*, *deep pink*, *turquoise*

1. Paint entire toy base yellow.
2. Paint each of the wheels a different color with a contrasting color in the wheel center.
3. Alternate colors for the dots and comma strokes. Use your imagination, and have fun!

## ~ NURSERY ~

The lovely pastel designs contained in this grouping are perfect for a nursery or a little girl's room. Many techniques are used but all are very easy to accomplish.

# STOOL

This stool is perfect to step on when one wants to "get big!" The eye-catching calico print of this design is a perfect accent that is carried throughout the grouping (FIG. 6-13).

**Fig. 6-13**
Children love stools to climb and sit on.

You will need:

- ☐ 12-inch-long (30.5 cm) × 6-inch-tall (15 cm) × 8¹/₂-inch-wide (21.3 cm) wooden stool
- ☐ acrylic paint in the following colors: *pastel pink, eggshell, pastel yellow, pastel blue, lavender, deep purple*
- ☐ sealer and finish of your choice
- ☐ 1-inch (2.5 cm) sponge brush
- ☐ liner brush
- ☐ #2 round brush

1. Prepare the wood as explained in chapter 2.
2. Paint each side panel with strips of painted calico. Alternate the four patterns shown in FIGS. 6-14, 6-15, 6-16 and 6-17 in strips approximately 1¹/₂ inches (4 cm) wide. You may draw your calico marking borders in any configuration you choose.

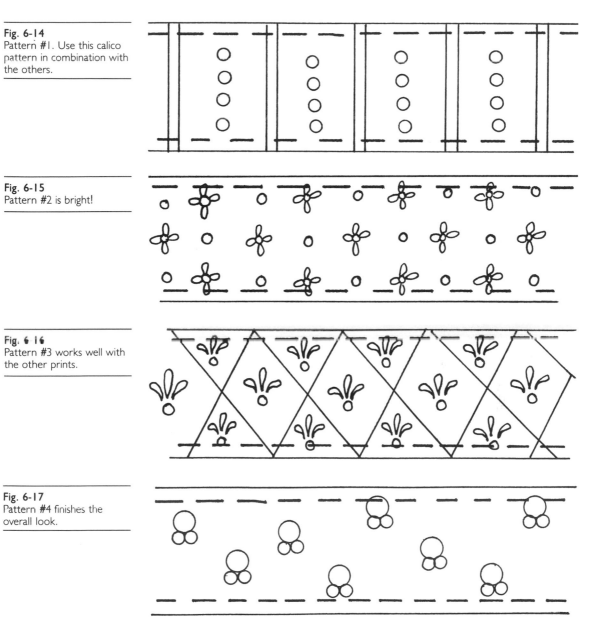

**Fig. 6-14**
Pattern #1. Use this calico pattern in combination with the others.

**Fig. 6-15**
Pattern #2 is bright!

**Fig. 6-16**
Pattern #3 works well with the other prints.

**Fig. 6-17**
Pattern #4 finishes the overall look.

Pattern #1: Paint the background *pale yellow*, and the stripes *pale blue*. Alternate strips with *eggshell* and *deep purple* for the dot stripes, and paint the stitching lines *eggshell* (FIG. 6-14).

Pattern #2: Paint the background *pale blue*, all dots *lavender*, the petal strokes *pale pink*, and the stitching lines *eggshell* (FIG. 6-15).

Pattern #3: Paint the background *pale pink*, the comma strokes and vertical and diagonal lines *light blue*, and the dots and stitching lines *eggshell* (FIG. 6-16).

Pattern #4: Paint the background *lavender*, the large dots *pink*, the small dots *yellow*, and the stitching lines *eggshell* (FIG. 6-17).

3. Paint the underside of the stool eggshell.

4. Paint the top of the stool and the stool edges pink.

5. Apply the finish of your choice according to manufacturer's instructions.

# BLOCKS

Pleasing to the eye and fun to play with, blocks are an age-old tradition. Why not make an entire set of alphabet letters and numbers? (FIG. 6-18).

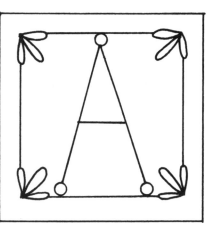

**Fig. 6-18** (Left)
A-B-C and 1-2-3 blocks are fun for children to play and learn with.

**Fig. 6-19** (Right)
Three comma strokes are used in each corner of the block.

You will need:

☐ 1³/4-inch (4.3 cm) wooden blocks (as many as you wish)

☐ acrylic paint in the following colors: *light blue, pale yellow, lavender, black, eggshell*

☐ 1-inch (2.5 cm) sponge brush

☐ #2 round brush

☐ liner brush

☐ sealer and finish of your choice

1. Prepare the wood for painting as described in chapter 2.

2. Draw a box ¹/4 inch (.6 cm) in from the edges of the blocks.

3. Paint the inner square your choice of color, and paint around the inner squares in a different color. Use different coordinating colors on each block; mix and match.

4. Paint three tiny commas in the four corners of the block as shown in FIG. 6-19.

5. Paint a numeral or letter in the center block square. Use the alphabet and numbers in chapter 4.

6. Seal the finished blocks according to the manufacturer's instructions.

# MIRROR

Place a colorful mirror on a baby's wall. You'll be delighted at the child's reaction as you hold her in front of the mirror and she encounters herself! (FIG. 6-20).

**Fig. 6-20**
Children are fascinated with mirrors. They will really enjoy this one.

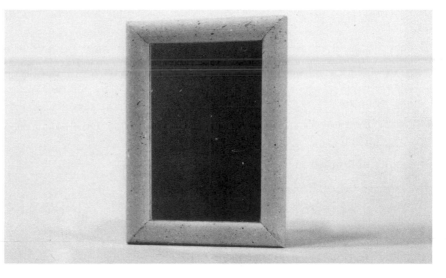

You will need:

☐ 7-inch-tall (17.5 cm) × 5¼-inch-wide (13.1 cm) wooden framed mirror

☐ pale blue acrylic paint

☐ dark blue acrylic paint

☐ white acrylic paint

☐ wide flat brush

☐ sealer and finish of your choice

☐ masking tape

☐ old toothbrush

1. Prepare the wood as explained in chapter 2.

2. Tape a sheet of paper over the mirror, being sure to bring the tape right up to, but not overlapping, the mirror frame.

3. Paint the frame pale blue.

4. Follow the instructions in chapter 4 and spatter the dark blue and white paint over the pale blue basecoat. Remove the paper and tape after dry.

5. Seal the wood on the mirror with the finish of your choice.

# SMALL ROCKING HORSE

This cute rocking horse design is sure to delight any little girl or boy (FIG. 6-21).

You will need:

☐ 8<sup>1</sup>/2-inch-tall (21.3 cm) × 7-inch-wide (17.5 cm) wooden rocking horse

☐ acrylic paint in the following colors: *pale pink*, *dark pink*, *white*, *black*, *burgundy*

☐ #10 flat brush

☐ #6 flat brush

☐ liner brush

☐ #2 round brush

☐ sealer and finish of your choice

1. Prepare the wood as explained in chapter 2.

2. Paint entire horse pale pink.

3. Paint edges of horse deep pink.

4. By side loading brush with deep pink paint, shade the edges of the front of the horse.

5. Spatter deep pink and white paint onto the front of the horse, following instructions in chapter 4.

6. Transfer the eye from FIG. 6-22 to the horse face, and paint it black. The dot and comma in the eye are highlights and should be painted white.

7. Side load the flat brush with burgundy, and paint the cheek of the horse.

8. Paint stitching lines with white around the outside edges of the entire horse.

9. Seal the horse with the finish of your choice.

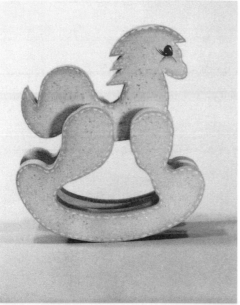

## LARGE ROCKING HORSE

**Fig. 6-2I** (Above Left)
The spattering techniques is
used well on this small
rocking horse.

**Fig. 6-22** (Above Right)
Transfer this eye pattern
after the spattering process,
then paint.

Bright and colorful, this rocking horse is certain to elicit a smile from any child (FIG. 6-23).

You will need:

- ☐ 14¹/₂-inch-wide (36.3 cm) × 14-inch-tall (35 cm) rocking horse
- ☐ acrylic paint in the following colors: *eggshell, pastel yellow, pastel blue, lavender, deep purple, pastel pink.*
- ☐ sealer and finish of your choice
- ☐ 1-inch (2.5 cm) sponge brush
- ☐ liner brush
- ☐ #2 round brush

1. Prepare the wood as described in chapter 2.
2. Paint the entire horse inside and out eggshell.
3. On the front of horse, draw patchwork sections either in strips of approximately 2 inches wide, or randomly create blocks of your own. Do the calico designs freehand, rather than tracing each part.
4. Paint calico sections following FIGS. 6-14 to 6-17 in styles and colors.
5. Seal the horse with the finish of your choice.

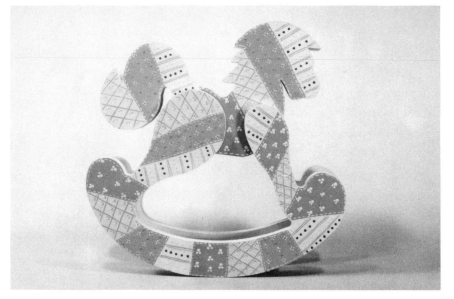

**Fig. 6-23**
The large rocking horse in this combination works perfectly well with the stool design.

# PASTEL WALL GATE

This cute wallpiece design will brighten any little girl's room with suggested movement and color! (FIG. 6-24).

**Fig. 6-24**
This softly colored wall gate would look cute in a child's room.

You will need:

- ☐ 6-inch-wide (15 cm) × 8-inch-tall (20 cm) flat wooden gate
- ☐ aqua acrylic paint
- ☐ light pink acrylic paint
- ☐ deep pink acrylic paint
- ☐ sealer and finish of your choice
- ☐ #10 flat brush
- ☐ #4 round brush
- ☐ 4-inch stuffed pig
- ☐ small bunch dried flowers in matching colors
- ☐ 1 yard (.9 m) 1/2-inch-wide (1.3 cm) aqua scallop-edged ribbon
- ☐ 1 yard (.9 m) 1/4-inch-wide (.6 cm) deep pink scallop-edged ribbon
- ☐ 3-inch (7.5 m) length 28-gauge cloth-covered wire
- ☐ hot glue gun or Crafter's Cement

1. Prepare the wood as described in chapter 2.
2. Paint the crossbars light pink and the background aqua.
3. Form commas and dots as shown in FIG. 6-24 with deep pink paint.
4. After the paint is dry, seal with the finish of your choice.
5. Glue the pig to the left side of the fence and the cluster of flowers to the right side.
6. Form a bow with the two ribbons together having 1 1/2-inch (4 cm) loops and 3-inch (7.5 cm) streamers. Secure with the 3-inch (7.5 cm) length of cloth-covered wire, twist wire ends, and trim away excess. Glue the bow over the ends of the flower.

# Special Holidays

$\mathcal{M}$ost people love to decorate their homes during special holidays, and painted holiday designs can be used and appreciated for many years. Take care when packing and storing the items from year to year to allow a minimum of wear. Wrap each piece in tissue paper, then place it in a sealed box. Don't place the pieces in areas that get too hot or cold. The more constant the temperature, the longer your treasured piece will last.

## TRICK-OR-TREAT BOX

A delightfully scary Halloween box can hold candy during this fun holiday season. Use these cute spider fellows to paint on other Halloween decorations of your choice (FIG. 7-1).

**Fig. 7-1**
This Halloween box can be filled with treats.

You will need:

- [ ] 5¹/₂-inch-tall (13.8 cm) × 9-inch-long (22.5 cm) × 6-inch-wide (15 cm) octagonal box with lid
- [ ] acrylic paint in the following colors: *black, red, white, gray*
- [ ] sealer and finish of your choice
- [ ] 1-inch (2.5 cm) sponge brush
- [ ] brushes: #6 flat, #2 flat, #4 round, #2 round, liner brush

1. Prepare the wood as explained in chapter 2.
2. Paint entire box bottom, inside and out, with orange paint.
3. Paint top of box lid with orange paint.
4. Paint edge of box lid with black paint.
5. Transfer large spider in FIG. 7-2 to box top.
6. Transfer smaller spiders (FIG. 7-3) to sides of box.
7. Paint spiderwebs gray.
8. Paint spiders black.

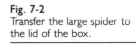

**Fig. 7-2**
Transfer the large spider to
the lid of the box.

**Fig. 7-3**
The small spiders can be used around the sides of the box.

9. Paint mouths. Then paint eyebrows with tiny comma strokes in red.

10. Paint teeth and eyes white.

11. Paint slits in eyes black.

12. Paint words on the front of box following the alphabet in chapter 4.

13. Seal box with finish of your choice.

## WELCOME SIGN

This delightful welcome sign is a wonderful gift for a new bride and groom. They can hang it near the door, welcoming all to their new home as well as remembering the year in which they were married (FIG. 7-4).

You will need:

☐ wooden hanging welcome sign of the size you desire

☐ acrylic paint in the following colors: *deep rose, burgundy, white, metallic gold, deep blue*

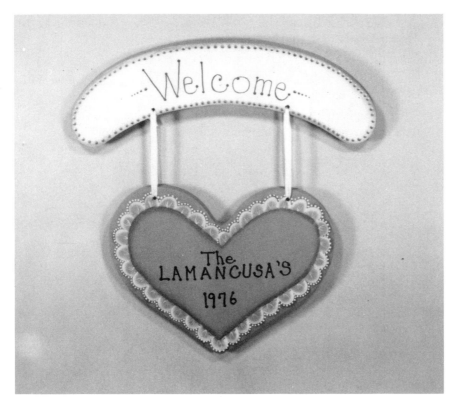

**Fig. 7-4**
A welcome sign makes a
nice gift.

- ☐ sealer and finish of your choice
- ☐ 1-inch (2.5 cm) sponge brush
- ☐ brushes: #10 flat, #6 flat, #2 round, #4 round, liner brush
- ☐ 24 inches (60.5 cm) ¼-inch-wide (.6 cm) double-face satin ribbon

1. Prepare the wood as explained in chapter 2.
2. Basecoat the entire heart deep rose.
3. Measure in ¾ inch (1.8 cm) from heart edge.
4. Side load a large flat brush with burgundy paint, and shade on inside of line.
5. Paint lace on outside of line using white paint and instructions in chapter 4.
6. Paint stitching line at lace edge using metallic gold paint.
7. Paint in name and date using deep blue paint and following alphabet in chapter 4.
8. Paint top of curved plaque eggshell. Paint the edges deep rose.

9. Side load a large flat brush with deep rose paint, and shade along the edges of the top of the curved plaque.

10. Center the word WELCOME and paint with deep blue paint.

11. Paint all the dots around the edge and on either side of the WEL-COME with metallic gold paint.

12. Seal the finished piece with a finish of your choice. If you wish to hang this design outside, be sure your finish will allow that.

# WOOD SLICE PICTURE FRAME

The slice of a tree made into a picture frame creates an effective look for a cherished photograph (FIG. 7-5).

**Fig. 7-5**
Using dots and comma strokes, decorate a slice of wood to encircle the photo of a loved one.

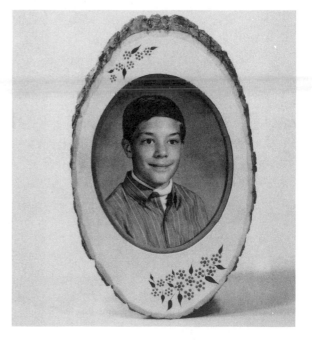

You will need:

☐ 10-inch-wide (25.5 cm) × 15-inch-tall (38 cm) wood slice picture frame

☐ acrylic paint in the following colors: *medium blue, burgundy, leaf green*

☐ brushes: #8 round, #6 round, and liner brush

☐ sealer and finish of your choice

1. Prepare the wood as explained in chapter 2.
2. Paint the inside edge of the frame medium blue.
3. Following the design in FIG. 7-6, paint dot flowers having blue petals and a burgundy center.
4. Paint the leaves green.
5. Seal the finished piece following manufacturers instructions.

**Fig. 7-6**
Do not transfer these patterns, use them as guidelines for freehanding.

# NOEL BOARD

Quick and simple, this stencil-like design goes on fast, bringing cheer throughout the season (FIG. 7-7).

**Fig. 7-7**
Paint a NOEL sign to greet the holiday season.

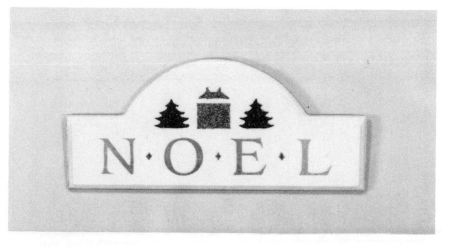

You will need:

☐ 16-inch-wide (40.5 cm) × 7-inch-tall (17.5 cm) wooden "noel" plaque
☐ acrylic paint in eggshell and metallic gold
☐ glitter paint in green and red
☐ brushes: #4 round, #2 round, #6 flat
☐ 1-inch (2.5 cm) sponge brush
☐ sealer and finish of your choice

1. Prepare the wood as explained in chapter 2.
2. The pictured plaque was purchased with the design precarved into the wood. If you are unable to find this type you may transfer the design from FIG. 7-8 and paint it.
3. Basecoat the entire plaque with eggshell acrylic paint.
4. Paint one ridge around the plaque with metallic gold paint.
5. Paint the letters metallic gold.
6. Paint the house and diamond shapes between the letters with red glitter paint.
7. The trees are green litter paint.
8. Apply the finish of your choice.

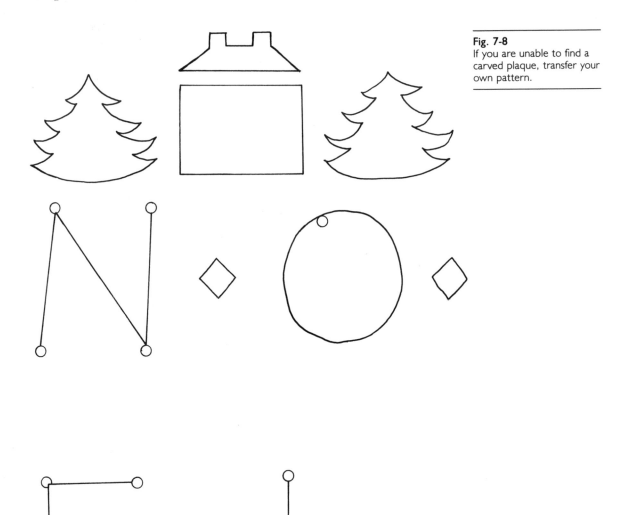

**Fig. 7-8**
If you are unable to find a carved plaque, transfer your own pattern.

## SCISSORS FOR MOM

Combine a novelty painted item such as these wooden scissors with decorative ribbon and dried flowers, then present it to mom on a special occasion (FIG. 7-9).

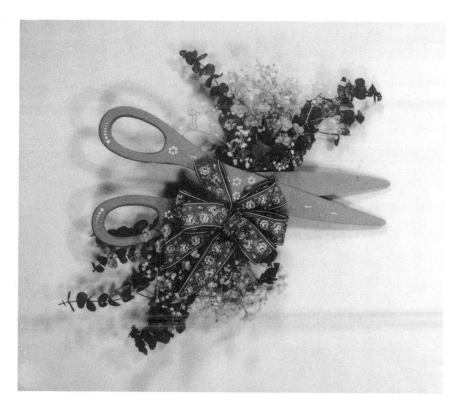

**Fig. 7-9**
A pair of wooden scissors
makes a welcome gift for
Mom.

You will need:

- [ ] 14-inch-long (35 cm) pair wooden scissors
- [ ] acrylic paint in the following colors: *celedon green, eggshell, rust*
- [ ] 1-inch (2.5 cm) sponge brush
- [ ] #2 round brush
- [ ] sealer and finish of your choice
- [ ] 2 yards (1.8 m) 1½-inch-wide (4 cm) floral print ribbon
- [ ] 1 ounce package preserved baby's breath
- [ ] 1 ounce bundle eucalyptus
- [ ] 1 stem rust silk flowers with 24 1-inch (2.5 cm) flowers
- [ ] 28-gauge cloth-covered wire
- [ ] 1 eggshell chenille stem
- [ ] adhesive of your choice

1. Prepare the wood as explained in chapter 2.
2. Basecoat scissors with green print.

3. Paint dot flowers along the base of the scissors with eggshell petals and rust centers.

4. Add long comma strokes with rust and a series of decreasing dots with eggshell on the scissor blades.

5. Add a row of decreasing dots on each handle of the scissors.

6. Break the eucalyptus and baby's breath into 9-inch (22.5 cm) stems. Form two bunches of the materials, each bundle containing 1/2 of the baby's breath and 1/2 of the eucalyptus. Use 1/2 the wire wrapped around each bundle to secure.

7. Cut the stem of silk flowers in half and place one half stem into each dried bundle. Use the wire wrapped around the stem of the flowers to secure. Trim away excess wire ends.

8. Glue the two floral bundles end to end on the back of the scissors.

9. Form a bow with the ribbon having eight 3-inch (7.5 cm) loops and two 6-inch (15 cm) streamers. Secure with chenille stem. Wrap the chenille stem around the cluster of flowers near the scissors. Form the excess chenille ends into a loop for hanging.

## BASKET OF WOODEN FLOWERS

Paint these clever wooden flowers, then place them into a lovely silk arrangement—and it never needs watering! (FIG. 7-10).

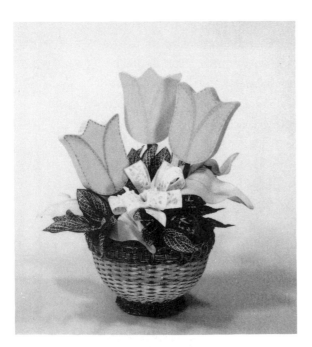

**Fig. 7-10**
After painting these wooden flowers, place them in an easy-to-create floral arrangement.

You will need:

- ☐ 3 wooden flowers on dowels 3³/4 inch (9.3 cm) tall × 3 inches (7.5 cm) wide
- ☐ acrylic paint in the following colors: *light turquoise, dark turquoise, light peach, dark peach, light rose, dark rose, green*
- ☐ brushes: #10 flat, #6 flat, and liner brush
- ☐ sealer and finish of your choice
- ☐ 1 bush silk pothos leaves
- ☐ 1 bush silk pepperomia leaves
- ☐ 1 basket 5¹/2-inch-wide (13.8 cm) × 4-inch-tall (10 cm)
- ☐ 4-inch (10 cm) block dry floral foam
- ☐ spanish moss
- ☐ 2 yards (1.8 cm) ⁷/8-inch-wide (2 cm) pink floral ribbon
- ☐ 1 eggshell chenille stem
- ☐ adhesive of your choice

1. Seal the wooden flowers following instructions in chapter 2.
2. Basecoat the entire flower with the light color paint, one color per flower.
3. Transfer the center V onto the flower following FIG. 7-11.

**Fig. 7-11**
Transfer only the center V
to the basecoated wood.

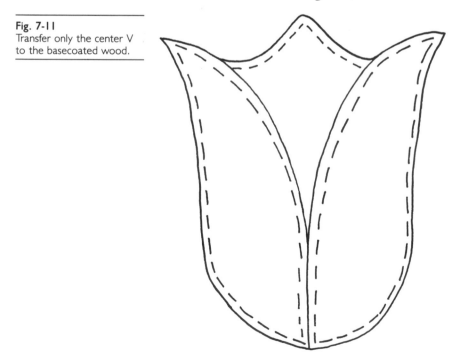

4. Side load the large flat brush with dark paint, and shade along the outside edges of the V in the center of the flower.

5. Using a liner brush and dark color paint, add stitching lines.

6. Paint the flower stems green.

7. Glue the foam block into the center of the basket. Cover with moss.

8. Insert flowers into the foam at three different heights.

9. Cut leaf bushes apart into sections, and insert stems around flowers in the basket.

10. Form a bow with the ribbon having 1¹/₂-inch (4 cm) loops and 2-inch (2.5 cm) streamers. Secure with the chenille stem. Twist the chenille stem ends and insert into foam just under the shortest flower.

# EASTER EGGS

Create eggs that will last a lifetime. The time you put into designing these can be enjoyed year after year (FIG. 7-12).

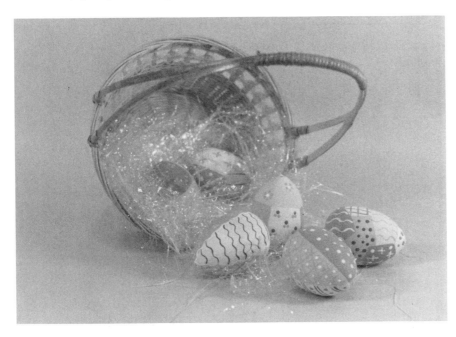

**Fig. 7-12**
Use imagination and lots of color when painting these Easter eggs.

You will need:

☐ six 2³/₄-inch (6.8 cm) wooden eggs

☐ pastel acrylic paints: *peach, white, blue, purple, yellow, green*

☐ sealer and finish of your choice

☐ brushes: #10 flat, #6 flat, #2 round, and liner brush

1. Seal the wood as explained in chapter 2.

2. With a pencil, draw sections on each egg to represent a calico design. Use the calico patterns throughout the pages of this book to paint each section of the egg. The section is always basecoated first, then the intricate designs are added freehand. Assort the colors to achieve a bright, cheerful look. Create your own set of calico designs if you choose.

3. Finish the eggs with a sealer following the manufacturers instructions.

# DAD'S LETTER BOX

This up-turned scoop is created especially for Dad. Deep, rich colors make it perfect for use in a den or office (FIG. 7-13).

**Fig. 7-13**
The rich colors of this scoop make it a perfect gift for Dad.

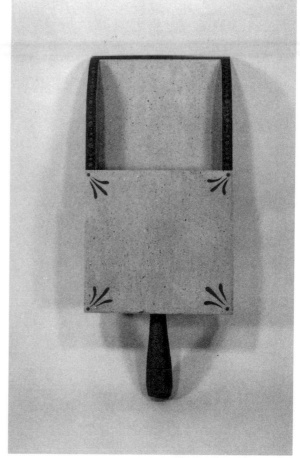

You will need:

☐ 18-inch-tall (45.5 cm) × 7¹/₂-inch-wide (18.8 cm) wooden scoop

☐ acrylic paint: *hunter green, rust, brown, tan*

☐ 1-inch (2.5 cm) sponge brush

☐ #4 round brush

☐ old toothbrush

☐ sealer and finish of your choice

1. Seal the scoop as directed in chapter 2.
2. Basecoat the handle in rust.
3. Basecoat the entire scoop, tan, and paint the edges hunter green.
4. Form three hunter-green comma strokes and a rust dot in each corner on the front of the scoop.
5. Add hunter dots of various sizes on the hunter edges of the box.
6. Follow the instructions for spattering in chapter 4. Use brown paint for spattering.
7. Apply the sealer of your choice.

# HOUSE HEART FRAME

Add decorative painting touches to miniature wood frames to spotlight special pictures (FIG. 7-14).

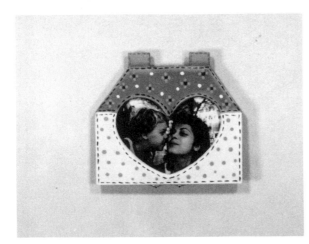

**Fig. 7-14**
A calico-painted house frame makes a special gift.

You will need:

☐ 4¹/₂-inch-wide (11.3 cm) × 4-inch-tall (10 cm) wooden house frame

☐ acrylic paint in the following colors: *eggshell, tan, rose, deep rose, dark blue, medium blue*

☐ brushes: #8 flat, #6 flat, and a liner brush

☐ sealer and finish of your choice

1. Prepare the wood as instructed in chapter 2.

2. Basecoat the lower portion of the house tan, the upper portion medium blue, and the chimneys rose.

3. Side load a flat brush with eggshell, and shade around the outside edges of the blue and tan parts of the house and around the center heart (FIG. 7-15).

**Fig. 7-15**
Use the pictured calico patterns, or create your own.

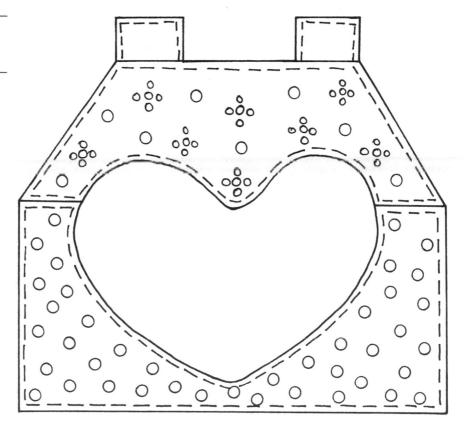

4. Side load the brush with dark rose, and shade along the chimney near the roof.

5. Add rose dots to the tan portion of the house.

6. Add rose dot flowers with dark centers to the top portion of the house. Add eggshell dots between the flowers on the roof of the house.

7. Add dark blue stitching lines around the tan and blue house sections and dark rose stitching lines around the chimneys.

# DOUBLE PICTURE FRAME

Double miniature frames are available when you need to spotlight two pictures (FIG. 7-16).

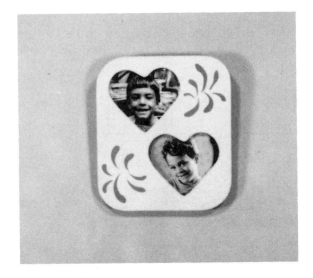

**Fig. 7-16**
You can purchase double miniature photo frames for multiple portraits.

You will need:

☐ 4-inch-wide (10 cm) × 4¹/₂-inch-tall (11.3 cm) double heart frame

☐ acrylic paint: *peach, celedon green, eggshell*

☐ brushes: #10 flat, #4 round

☐ sealer and finish of your choice

1. Prepare the wood following instructions in chapter 2.

2. Basecoat the entire frame peach.

3. Following FIG. 7-17, paint green comma strokes and eggshell dots onto the peach frame.

4. Seal the finished frame.

# VALENTINE HEARTS

Delicate and lovely, these hearts are a cute Valentine decoration or a gift that will be greatly appreciated. The candle allows for a soft, romantic look to the finished design (FIG. 7-18).

You will need:

☐ 7-inch-wide (17.5 cm) × 5-inch-tall (12.5 cm) × 1¹/₂-inch-thick (4 cm) heart candleholder

**Fig. 7-17**
Freehand the flowers and
comma strokes onto the
frame.

**Fig. 7-18**
Wooden Valentine hearts
make warm gifts.

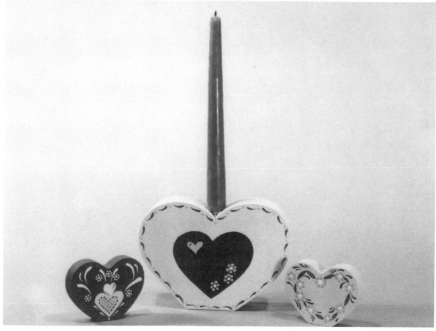

- [ ] two 3½-inch-wide (8.8 cm) × 3-inch-tall (7.5 cm) wooden table hearts
- [ ] acrylic paint: *white, red, light pink, dark green*
- [ ] 1-inch (2.5 cm) sponge brush
- [ ] brushes: #4 flat, #2 flat, #4 round, #2 round, and a liner brush
- [ ] sealer and finish of your choice

For all hearts: prepare the wood as explained in chapter 2.

# Large Heart

1. Basecoat the entire heart white.
2. Transfer the design in FIG. 7-19.
3. Paint the center heart red.
4. The small heart in the upper left corner of the center heart is pink with red comma strokes inside and green comma strokes on the rest of the heart.
5. Dot flowers in the center heart have pink petals and white centers.
6. Comma strokes around the outside edge of the large heart are red with pink dots.
7. Apply the finish of your choice.

**Fig. 7-19**
Transfer the design onto the large candle holder heart.

# Floral Design

1. Basecoat the heart light pink.
2. Paint the flowers with dark pink petals and white centers (FIG. 7-20).
3. Comma strokes are green, and ribbon between the flowers are red.
4. Seal the finished heart.

# Heart and Comma Design

1. Basecoat the heart red.
2. Paint the larger inside heart pink and the smaller inside heart white (FIG. 7-21).

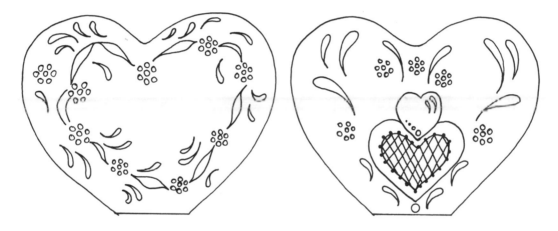

**Fig. 7-20** (Left)
A delicate ribbon flows easily between the flowers in this design.

**Fig. 7-2l** (Right)
The repetition of heart shapes makes this an interesting design.

3. Both inside hearts use red for the painting inside them.
4. Commas on the medium heart are white, and the dot flowers are pink.
5. Apply sealer of your choice.

# MOM'S TREASURE BOX

This lovely little chest is a perfect gift to hold mom's treasures, such as important notes, jewelry, or personal items (FIG. 7-22).
   You will need:

☐  5-inch-long (12.5 cm) × 3¹/₂-inch-tall (8.8 cm) × 3-inch-wide (7.5 cm) chest with lid

☐  acrylic paint in the following colors: *rose, dark rose, white, celedon green, peach*

☐  1-inch (2.5 cm) sponge brush

**Fig. 7-22**
Mom will love this treasure
box to hold her most
personal items.

☐ #4 round brush

☐ #2 round brush

☐ #4 flat brush

☐ liner brush

☐ sealer and finish of your choice

1. Seal the box following instructions in chapter 2.

2. Basecoat the entire box rose.

3. Transfer the designs from FIGS. 7-23, 7-24, and 7-25. Place them in their proper location on the box. The lace, extra dots, and flower centers are white.

4. Paint the commas green and the flowers peach.

5. Apply finish to the completed box.

# WALL FENCE

This cute wooden gate can be hung as is, or you can glue a painted animal, perhaps a tall goose, to the side near the flowers (FIG. 7-26).

You will need:

☐ 6-inch-wide (15 cm) × 8-inch-tall (20 cm) wooden wall gate

☐ brown acrylic paint

**Fig. 7-23**
Transfer this design to the top of the box.

**Fig. 7-24** (Above Left)
This design was created for the front and back of the box.

**Fig. 7-25** (Above Right)
The commas and dots were situated to fit perfectly on either side of the box.

- [ ] tan acrylic paint
- [ ] rust acrylic paint
- [ ] sealer and finish of your choice
- [ ] #10 flat brush
- [ ] #4 round brush
- [ ] small cluster of dried materials
- [ ] 28-gauge cloth-covered wire

**Fig. 7-26**
Contrasting colors and comma strokes make this an interesting design.

- ☐ 1 yard (.9 m) of ¹/₂-inch-wide (1.3 cm) lace-edged rust minidot ribbon
- ☐ adhesive of your choice

1. Prepare the wood as explained in chapter 2.
2. Basecoat the crossbars on the fence tan and the rest of the fence brown.
3. Paint the rust commas and the dots on the crossbars of the fence as shown.
4. Glue the floral cluster to the right side of the fence.
5. Form a four-loop bow with ribbon, and secure with cloth-covered wire. Trim the wire ends, and glue the bow over the flower stems.

# Home Decorating

*D*ecorative painted touches can be used to enhance the look of many functional home decor items. The beauty in the following pieces is in their use of colorful striping and accents. A few brush techniques finish the pieces and add that special handmade look.

## CABINET

Choose an unfinished cabinet style that fits the overall look and feel of your room. The painted touches you add will vary with the type of cabinet you select. Study the piece, and select areas that can be sectioned off and painted a coordinating color. Your design can vary from the project in FIG. 8-1, but use it as an example, then add your own creativity.

You will need:

- $16^1/_2$-inch-tall (41.8 cm) × 13-inch-wide (32.5 cm) × $6^1/_4$-inch-wide (15.6 cm) unfinished cabinet with two inside shelves
- deep blue acrylic paint for overall basecoat
- deep rose acrylic paint for trim
- metallic gold acrylic paint from trim
- 1-inch (2.5 cm) sponge brush
- #6 flat brush
- #5 round brush
- sealer and finish of your choice

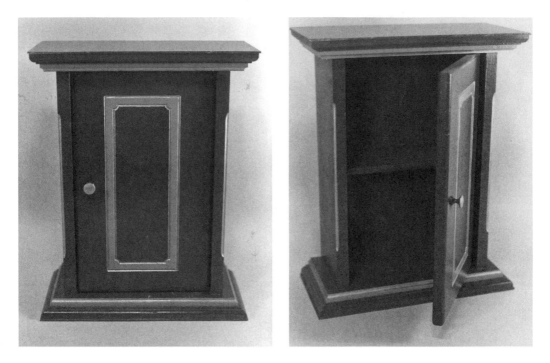

1. Prepare the cabinet for painting as explained in chapter 2.

2. Determine the areas on the cabinet which will be painted gold or rose, and paint all other areas deep blue. When dry, apply a second coat if needed.

3. Use the flat brush to paint the following areas metallic gold: the top stripe around base of cabinet, the bottom stripe around top of cabinet, and the two grooved edges on either side of cabinet front.

4. Use the round brush to paint the carved section on the front of the cabinet door and the door knob metallic gold.

5. Use the flat brush and deep rose paint to paint the following sections: inside wooden embellishment on cabinet front, second strip on base of cabinet, strip above gold stripe on top of cabinet.

6. Seal the finished cabinet following manufacturer's instructions.

Be careful when painting the inside of cabinet. Allow areas to dry before continuing. Leave door open as inside paint is drying (FIG. 8-2).

**Fig. 8-1** (Left)
This lovely painted cabinet is a perfect accent to any formal room.

**Fig. 8-2** (Right)
Leave the cabinet door open while paint is drying.

## SHELF

This versatile shelf can be used to display treasured items either resting on the shelf itself or hanging from hooks. It has been painted to coordinate with the cabinet design (FIG. 8-3).

**Fig. 8-3**
Trinkets and plates will find a lovely home on this coordinated shelf unit.

You will need:

☐  22-inch-wide (55.5 cm) x 7-inch-tall (17.5 cm) shelf with three pegs
☐  medium French blue acrylic paint for overall basecoat
☐  deep rose acrylic paint for trim
☐  metallic gold acrylic paint for trim
☐  1-inch (2.5 cm) sponge brush
☐  #6 flat brush
☐  #2 round brush
☐  sealer and finish of your choice

1.  Prepare the shelf for painting as explained in chapter 2.

2.  Basecoat the entire top of shelf and over the side along one strip with blue paint.

3.  Skip two stripes and paint center stripe blue.

4.  Skip two more stripes and paint remaining portions of entire shelf blue.

5.  With the flat brush, paint one stripe on either side of the center blue stripe metallic gold.

6.  Paint the stripe next to each gold stripe deep rose.

7.  Paint the tip of each handle with dots using the end of paintbrush or other means explained in chapter 3. The center rose dot should be surrounded with 5 gold dots (FIG. 8-4).

8.  Using the round brush, create comma strokes around the peg as shown in FIG. 8-4. Dots above and below the peg on the shelf should be made in decreasing size from peg outward with a dot of metallic gold in the center of each.

9.  Seal the shelf following the manufacturer's instructions on the sealer package.

**Fig. 8-4**
The embellishments on the
shelf are easy to create
using commas and dots.

# SCONCE

A candle sconce will add a beautiful touch of light to the area of the room in which it is placed. In place of a candle, you might wish to add a small bud vase of flowers instead (FIG. 8-5).

You will need:

☐ 16-inch-tall (40.5 cm) x 4¹/₂-inch-wide (11.3 cm) wall sconce

☐ 1³/₄-inch-tall (4.3 cm) wooden candle cup

☐ medium French blue acrylic paint for overall basecoat

☐ deep rose acrylic paint for trim

☐ metallic gold acrylic paint for trim

☐ 1-inch (2.5 cm) sponge brush

☐ brushes: #6 flat, #6 round, #4 round, #2 round, liner brush

☐ sealer and finish of your choice

1. Prepare the sconce for painting as explained in chapter 2.

2. Basecoat entire top of sconce and top and bottom of sconce shelf with blue paint. Paint the candle cup blue, inside and outside.

3. With flat brush and metallic gold paint, paint the first stripe along sides of sconce and the top and bottom strip of sconce shelf.

4. Paint the top ridge of the candle cup gold.

**Fig. 8-5**
The sconce pictured is lovely with or without a candle enclosed in the candle cup.

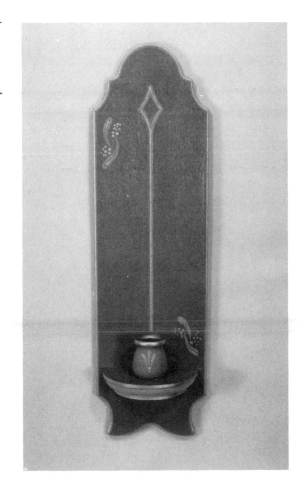

5. Using deep rose paint, paint back stripe around sides of sconce deep rose. Also paint center stripe of sconce shelf, as well as carved indentation down center of sconce face.

6. With gold paint and liner brush, paint a single line down center of indentation on sconce face which was painted rose in Step #5.

7. To finish the candle cup, paint three comma strokes with a #2 round brush and mauve paint on front. Paint three metallic gold dots of descending size under the comma strokes.

8. Paint the design in FIG. 8-6 on upper left corner of sconce and the design in FIG. 8-7 on lower right corner. The commas are formed as explained under Triple Commas in chapter 3—with the largest being rose, the middle being blue, and the center being metallic gold. The dots near the commas are metallic gold.

**Fig. 8-6** (Left)
This quick design should be placed at the upper left corner of the sconce.

**Fig. 8-7** (Right)
An opposite design is placed at the lower left on the front of the sconce.

9. After all paint is dry, glue candle cup to the sconce shelf.

10. Seal the sconce following the manufacturer's instructions.

## CARRIAGE CLOCK

Decorative strokes beautifully enhance this lovely carriage clock which becomes an eye-catching companion piece when displayed with the shelf, cabinet, and sconce (FIG. 8-8).

You will need:

☐ 9¹/₂-inch-wide (23.8 cm) x 9-inch-tall (22.5 cm) carriage clock

☐ medium French blue acrylic paint for overall basecoat

☐ deep rose acrylic paint for trim

**Fig. 8-8**
The final piece to our grouping is a dazzling carriage clock.

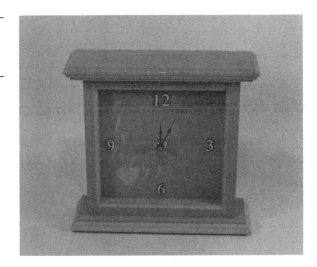

- ☐ metallic gold acrylic paint for trim
- ☐ clock works to fit the clock
- ☐ stick-on clock numerals—3, 6, 9, and 12
- ☐ 1-inch (2.5 cm) sponge brush
- ☐ brushes: #6 flat, #6 round, #4 round, #2 round
- ☐ sealer and finish of your choice

1. Prepare the carriage clock for painting as explained in chapter 2.

2. Basecoat entire clock with medium blue paint.

3. Using flat brush, paint a rose stripe around the frame of the clock face. Paint a rose stripe around the top and bottom of the clock edge.

4. Paint a gold stripe above the rose stripe on top of the clock and below the stripe on the bottom of clock.

5. Follow instructions in chapter 2 and transfer heart design in FIG. 8-9 to lower left corner of the clock face. Commas and dots are best done freehand.

6. The heart and all comma strokes should be painted deep rose. The dots are metallic gold, and one is placed at the top of each comma stroke. The comma strokes and dots inside of the heart are metallic gold.

7. Follow manufacturer's instructions and attach clock works. Place the numerals equally spaced around the clock face in their proper locations.

8. Seal the clock according to the manufacturer's instructions.

**Fig. 8-9**
Use this decoration to place
on the lower left side of the
front of the clock.

# HOME IS WHERE THE HEART IS PLAQUE

Loving statements can be made with decorative carved wood pieces. This
design was created using a plaque that had the house and wording pre-
carved (FIG. 8-10). You might wish to paint the same design on a plaque of
your choice using our alphabet.

You will need:

- ☐ 16-inch-wide (40.5 cm) × 7-inch-tall (17.5 cm) precarved plaque
- ☐ medium teal acrylic paint
- ☐ deep teal acrylic paint

**Fig. 8-10**
Sentiment adds love to your designs.

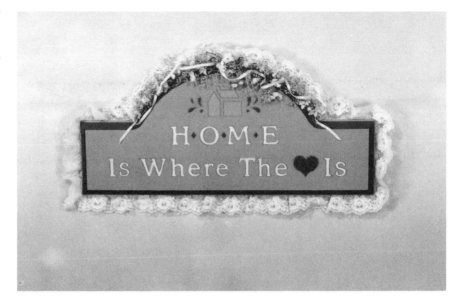

- ☐ deep rose acrylic paint
- ☐ eggshell acrylic paint
- ☐ 1-inch (2.5 cm) sponge brush
- ☐ #4 flat brush
- ☐ #4 round brush
- ☐ spray or brush-on sealer of your choice (matte, gloss, or satin finish)
- ☐ 1¹⁄₃ yard (1.2 m) of 1-inch-wide (2.5 cm) eggshell gathered lace
- ☐ 1 ounce package of peach gypsophila
- ☐ 1 ounce package eggshell hill flowers
- ☐ 1 stem peach silk gypsophila having 16 1-inch (2.5 cm) flowers
- ☐ 1 yard (.9 m) ¹⁄₈-inch-wide (.3 cm) pale blue double-faced satin ribbon
- ☐ hot glue gun or Crafter's Cement

1. Prepare the wood for painting as explained in chapter 2.
2. Basecoat the entire piece with medium teal paint.
3. Paint the top stripe around side of the plaque deep teal and the second stripe deep rose.
4. On top of plaque: house is painted *deep rose*, hearts, commas, and spacers between "HOME" are *deep teal*, and all letters are painted eggshell.
5. If a precarved plaque is unavailable, transfer patterns from FIG. 8-11, and paint as explained above.

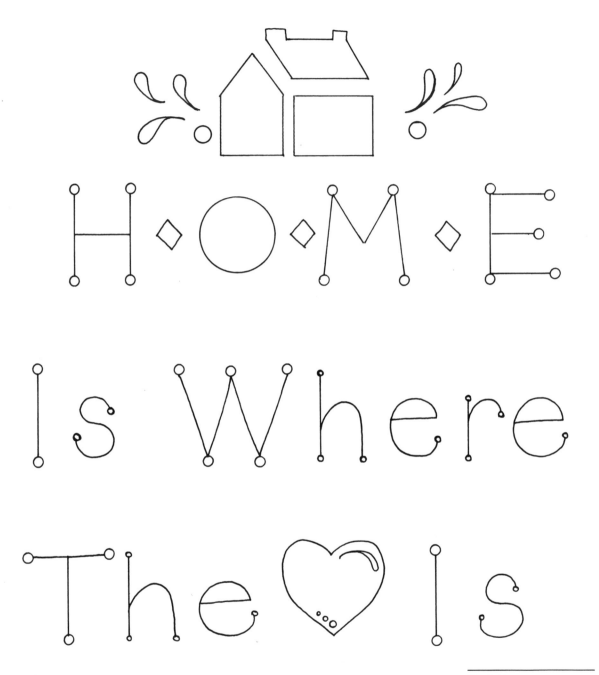

6. After the paint is dry, seal the plaque according to manufacturer's instructions.
7. Glue the gathered lace around the outside back edge of the plaque.
8. Break dried peach gypsophila into pieces 2 inches (5 cm) long. Start-

**Fig. 8-11**
Use this diagram for letters and placement, or create your own using your imagination.

ing at the top center, glue pieces next to each other down either side of the curved portion of the plaque.

9. Glue hill flowers with 1-inch (2.5 cm) stems among the dried flowers.

10. Cut the stems of silk flowers to lengths of 1¹/₂ inch (4 cm), and glue them equally spaced between the drieds in the design.

11. Glue the double-faced satin ribbon through the drieds by attaching one end of a 14-inch (35 cm) section to the plaque at one end, then allowing the ribbon to swag to another location 2 inches (5 cm) away and gluing down another ¹/₄-inch (.6 cm) length of ribbon. Continue across the entire top of the plaque leaving 2-inch (5 cm) streamers on either side (FIG. 8-12).

**Fig. 8-12**
Glue flowers and tiny ribbons above the plaque.

## BRAIDED BREAD-DOUGH WREATH

All of your painting surfaces need not be wood. Consider using this delightful recipe for bread dough to form your wreath, then have fun painting it! (FIG. 8-13).

You will need:

☐ 10-inch (25.5 cm) bread-dough wreath (follow instructions later to form and bake wreath)

☐ acrylic paint in the following colors: *turquoise, deep blue, coral, eggshell, deep rose*

☐ #6 flat brush

☐ #2 round brush

☐ liner brush

☐ sealer and finish of your choice

☐ 2 yards (1.8 m) ¹/₂-inch-wide (1.3 cm) eggshell scallop-edged ribbon

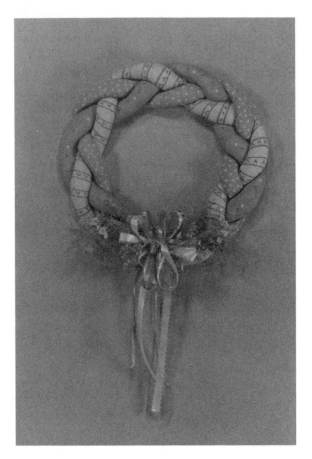

**Fig. 8-13**
All painted pieces do not
need to be wood; here we
have a bread-dough wreath.

☐  2 yards (1.8 m) ¹/₄-inch-wide (.6 cm) coral scallop-edged ribbon
☐  2 yards (1.8 m) ¹/₄-inch-wide (.6 cm) turquoise scallop-edged ribbon
☐  1 ounce bunch assorted dried flowers containing flowers in colors to
   match the ribbon and paint
☐  hot glue or Crafter's Cement

1. You will be following the sections of the braid, painting each section
   as though it were continuous. Follow the drawings in FIG. 8-14 to paint
   each of the sections.

2. Form a bow with three ribbons together having eight 2¹/₄-inch (5.6
   cm) loops and 8-inch (20 cm) streamers.

3. Form two clusters of drieds with 1-inch stems and glue them end to
   end at the join spot on the wreath.

4. Glue the bow over the dried material ends.

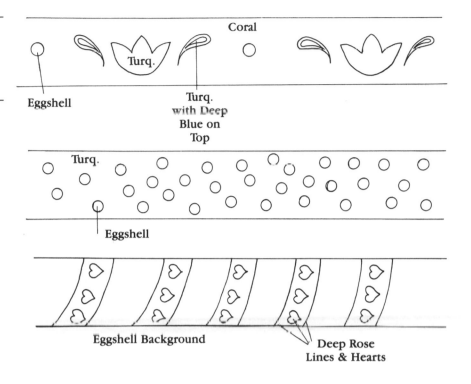

**Fig. 8-14**
Paint one of each of these designs the sections of the braid of the bread-dough wreath to signify a calico pattern look.

## Making the Bread-Dough Wreath

Recipe:

4 cups flour
1 cup salt
1¹/₂ cups hot running tap water

1. Mix the hot water and salt together until the salt is nearly all dissolved. This can take 1 to 1¹/₂ minutes.

2. Slowly add the flour until the water is absorbed.

3. Work in the bowl with your hands to further mix the dough.

4. Knead the dough on a smooth surface for a few minutes until it is smooth and pliable.

5. Divide the dough into 3 sections. Roll each section to form a snake-like form approximately 1¹/₂ inches (4 cm) wide. Each roll should measure 32 inches (.8 m)−36 inches (.9 m) long.

6. Begin pinching all three rolls together at one end so they are secured together. Add a drop of water between the spots where the bread dough joins if necessary.

7. Braid the entire length of the rolls. Pinch the three ends together again.

8. Form a circle with the braid approximately 10 inches (25.5 cm) in diameter. Secure both ends together at the location they join, trimming off any excess bread dough.

9. Bake the wreath immediately on a cookie sheet in a 275-degree oven for approximately 6-8 hours. It should be removed when it begins to turn golden in color. To test doneness, push on the wreath at the thickest part. It should be hard to the touch without any give.

10. Seal the finished piece with a spray or brush-on sealer following manufacturer's instructions. Be sure to completely cover the wreath—front, back and sides—to eliminate problems.

## WELCOME SLATE CHECKERBOARD

A popular way of spending time together in days gone by is by playing checkers. This old fashioned checkerboard reminds us of those days and allows us to again relive and enjoy the age-old game of checkers (FIG. 8-15).

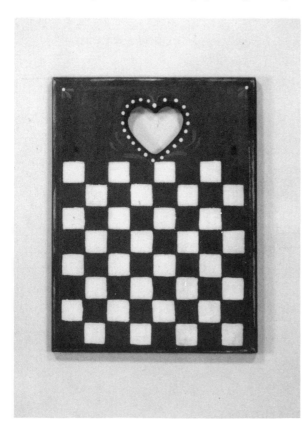

**Fig. 8-15**
Checkers is a game of long ago that is still popular today.

You will need:

☐ 9-inch-wide (22.5 cm) x 12-inch-tall (30.5 cm) checkerboard plaque and checkers

☐ hunter green acrylic paint

☐ eggshell acrylic paint

☐ rust acrylic paint

☐ burnt umber oil paint

☐ 1-inch (2.5 cm) sponge brush

☐ #6 round brush

☐ #10 flat brush

☐ sealer and finish of your choice

☐ sandpaper

☐ rags

1. Prepare the plaque for painting as described in chapter 2.

2. Paint the eggshell checkerboard blocks using the flat brush and eggshell paint. The pattern should be included with the plaque or marked on the plaque, but if not, lightly trace your own on following the example in FIG. 8-16. Each block is 1 inch (2.5 cm) and each row has 4 blocks. A total of 8 rows exist on the plaque.

**Fig. 8-16**
The checkerboard blocks are approximately 1 inch each.

3. Paint the remainder of the plaque hunter green.

4. Form eggshell dots around the edge of the heart. Follow the diagram in FIG. 8-17 to form comma strokes around the heart.

5. Follow the diagram in FIG. 8-18 to form rust comma strokes and eggshell dots in the top two corners of the plaque.

6. Follow the instructions in chapter 5 to country-sand the plaque edges; then antique the entire finished piece.

**Fig. 8-17** (Left) Paint this design at the top of the checkerboard plaque.

**Fig. 8-18** (Right) Embellishments are even added to the corners of the plaque.

## RIBBON-EMBELLISHED PAINTED STOOLS

For quickness and ease, cutout ribbon designs can be applied to decorative finishes in place of painting these intricate looks. The colors of the decorative piece can then be coordinated with the colors in the chosen ribbon pattern (FIG. 8-19). When choosing a ribbon design, look for #40 cotton print ribbon. Choose a design you like, then cut out the individual pieces to apply.

You will need:

☐ wooden stool of your choice

**Fig. 8-19**
Using ribbon cutouts instead
of intricate paintings can be
fun!

- [ ] ribbon cutouts to apply (number will depend on how you decide to use them)
- [ ] at least two different acrylic paints of coordinating colors
- [ ] sealer or finish of your choice
- [ ] white craft glue or spray adhesive
- [ ] 1-inch (2.5 cm) sponge brush
- [ ] #8 or #10 flat brush

1. Prepare the wood as described in chapter 2.

2. Basecoat the entire piece with one color of acrylic paint.

3. Attach ribbon motifs by placing white craft glue or spray adhesive on the back and apply in place on the stool.

4. Use the second color of paint to accent the stool. Apply in locations of your choice such as around sides of the stool top, down the edges on the sides, or accenting embellishments such as cutout hearts or raised knobs. See color photos in center section for some ideas.

5. Follow manufacturer's instructions for sealing design.

# DOUBLE DESKS

Reminding us of school days and adding to the country decorating theme is this delightful set of painted desks (FIG. 8-20). For an old fashioned look, sand and antique the piece after it has been painted.

**Fig. 8-20**
These schoolhouse desks make a lovely country room accent.

You will need:

☐ 11-inch-long (28 cm) × 7-inch-tall (17.5 cm) × 4-inch-wide (10 cm) wooden double desks

☐ eggshell acrylic paint

☐ rust acrylic paint

☐ navy blue acrylic paint

☐ 1-inch (2.5 cm) sponge brush

☐ #6 round brush

☐ #2 round brush

☐ #8 flat brush

☐ sealer and finish of your choice

1. Prepare desks for painting as described in chapter 2.

2. Paint the entire piece eggshell.

3. Paint the base of piece and the edges of desk legs with blue paint.

4. Paint edges of seats and desk top with rust paint.

5. Transfer apple design in FIG. 8-21 to top right corner of one desk and paint as shown.

6. Transfer heart design in FIG. 8-22 to seats of both desks and paint. Commas and dots are better done freehand.

7. Transfer heart design to top right corner of top of other desk. Paint.

8. Seal desks following manufacturer's instructions.

**Fig. 8-21** (Left)
Trace this apple design and transfer to the top of one of the desks.

**Fig. 8-22** (Right)
Use this heart design on the seats of the desk.

# PAINTED CITY FLORAL DESIGN

After painting these cute little city buildings, place them to rest in an easy-to-do dish floral design (FIG. 8-23).

You will need:

- ☐ wooden buildings approximately 1¹/₂ inches (4 cm) − 2 inches (5 cm) wide and 2 inches (5 cm) − 3 inches (7.5 cm) tall including: barn, church, building with slant roof, 2 small slanted buildings.

- ☐ acrylic paints of coordinating colors including: *rust, eggshell, deep coral, medium blue, gray, brown, tan,* and *black*

- ☐ #8 flat brush

- ☐ #2 flat brush

- ☐ liner brush

- ☐ sealer and finish of your choice

## Materials for floral design

- ☐ 11-inch (28 cm) rust shallow dish

- ☐ 6-inch (15 cm) Spanish moss wreath

**Fig. 8-23**
Painted pieces can be added
into floral arrangements.

☐   1 block dried floral foam

☐   1 package green moss

☐   2 ounce package assorted dried and preserved flowers in colors that coordinate with houses.

☐   U-shaped craft pins

☐   hot glue gun and glue sticks

1.  Prepare the wood pieces as described in chapter 2.

2.  Paint the houses with the following colors:

    ~   #1 barn: Paint the base *brown*, the roof *blue* and the silo *tan*.

    ~   #2 church: Paint the base *eggshell*, the roof *rust*, and the inside windows *tan*.

    ~   #3 building with slant roof: Paint the base *blue* and the roof *deep coral*.

    ~   #4 small slanted building: Paint the base *deep coral* and the roof *eggshell*.

    ~   #5 small slanted building: Paint the base *gray* and the roof *blue*.

3.  Add details shown in FIG. 8-24 for each building with black paint and liner brush.

4.  Seal the buildings as described in manufacturer's instructions.

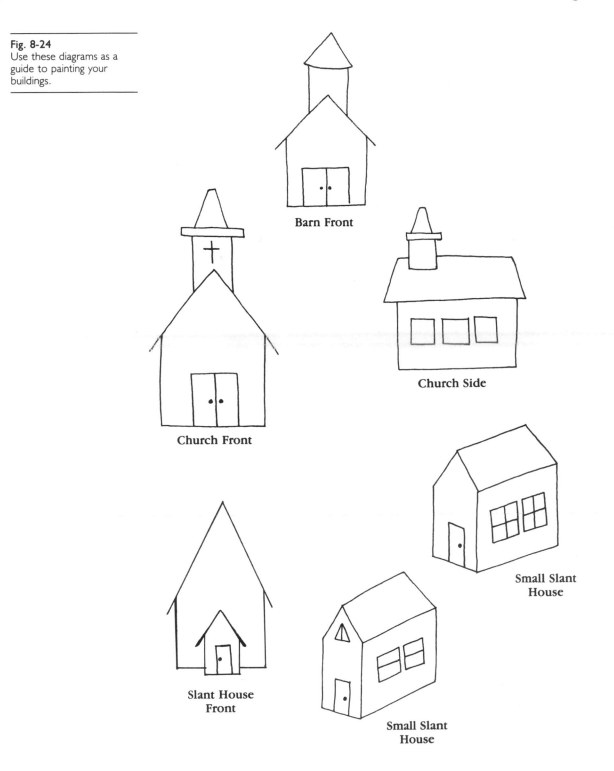

**Fig. 8-24**
Use these diagrams as a guide to painting your buildings.

Barn Front

Church Side

Church Front

Small Slant House

Slant House Front

Small Slant House

To form flower arrangement:

5. Glue slices of foam into dish so entire dish is covered. Foam should not extend above dish edge.

6. Completely cover foam with moss, and secure in place with pole pins.

7. Glue wreath standing on edge near back of dish. Insert ∪-shaped pins to secure.

8. Arrange buildings as desired onto foam, gluing in place where you wish.

9. Break off various lengths of flowers 2 inches (5 cm) – 8 inches (20 cm) and insert around and through buildings to give appearance of vegetation.

# SPONGE-PAINTED WALLBOX

This tall wallbox is a perfect accent for placing on the fireplace hearth or setting near a doorway. The technique is easy, and the florals are randomly arranged for beauty and ease (FIG. 8-25).

You will need:

☐ 5-inch-wide (12.5 cm) × 18-inch-tall (45.5 cm) × 4¹/₂-inch-deep (11.3 cm) wooden wallbox

☐ rust acrylic paint for overall basecoat

☐ eggshell acrylic paint for sponge technique

☐ medium blue acrylic paint

☐ deep green acrylic paint

☐ 1-inch (2.5 cm) sponge brush

☐ 2-inch (5 cm) pieces of household sponges

☐ #8 flat or round brush

☐ liner brush

☐ sealer and finish of your choice

☐ 1-pound bundle of assorted dried flowers including: eucalyptus, gypsy grass, gypsophila, and Florentine

1. Prepare the wall box for painting as described in chapter 2.

2. Paint the entire box inside and out with rust paint.

3. Using sponge pieces and eggshell paint, follow instructions in chapter 5 to apply the sponge look to the design.

**Fig. 8-25**
This wallbox is a wonderful
room accent when placed
on the hearth next to the
fireplace.

4. The flower design on the front of the box was precarved and pur-
   chased on the box. If you are unable to find this piece, transfer the
   design in FIG. 8-26 to the front of the box.

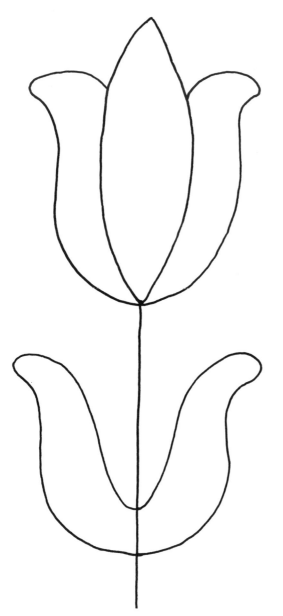

**Fig. 8-26**
You may use this design on your wallbox, or add your own touch.

5. Paint the flower blue and the stem and leaves green.

6. Randomly insert the drieds to achieve a full look.

# DECORATIVE ACCENTS

Whatever wooden pieces you want to decorate can easily and quickly be done by choosing elements from chapter 3 to apply to your painted

pieces. The following pieces were simply decorated with dots and commas so even though their designs look elaborate to the viewer, they were completed quickly. For each piece, first prepare the wood for painting as described in chapter 2. Each is basecoated with the specified color, and decorations were added as described. When finished, seal the design with the sealer of your choice. All designs were applied freehand.

# Rolling Pin

- ☐  walnut oil-based stain
- ☐  rust acrylic paint
- ☐  eggshell acrylic paint
- ☐  deep green acrylic paint

Follow the photo (FIG. 8-27) and the diagram (FIG. 8-28).

**Fig. 8-27**
Dots and commas were used to quickly decorate this decorative rolling pin.

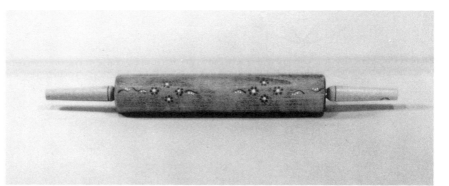

**Fig. 8-28**
Use two of these designs side by side to decorate the rolling pin.

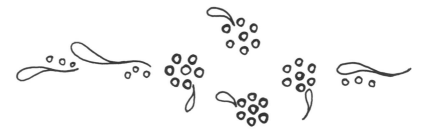

# Triple Heart Pegs

- ☐  tan acrylic paint
- ☐  brown acrylic paint
- ☐  eggshell acrylic paint

See photo (FIG. 8-29) and diagram (FIG. 8-30).

**Fig. 8-29**
This set of triple wall hearts
can be useful or decorative.

**Fig. 8-30**
Decorate the hearts as you
choose, or follow the ideas
here.

# Index